IMAGES
of America

OXFORD

IMAGES
of America

OXFORD

The Oxford Museum

ARCADIA
PUBLISHING

Published by Arcadia Publishing
Charleston, South Carolina

Printed in the United States of America

Library of Congress Control Number: 2023931722

For all general information, please contact Arcadia Publishing:
Telephone 843-853-2070
Fax 843-853-0044
E-mail sales@arcadiapublishing.com
For customer service and orders:
Toll-Free 1-888-313-2665

Visit us on the Internet at www.arcadiapublishing.com

CONTENTS

Acknowledgments

During my presidency at the Oxford Museum, I raised the idea of creating a new book for the museum since one had not been composed in 20 years. As history would have it, a worldwide pandemic consumed our thoughts and good intentions until the danger had passed.

I am very proud of this book, as it took many months of collaboration and effort from a team of volunteers to assemble. I am most grateful to them.

I would personally like to acknowledge and thank Stuart Parnes. He is the past president of the museum and volunteer curator of the museum's collection. As such, he has a vast knowledge of the contents of the collection and its valuable photographs, which you will see in this book. He has culled through thousands of photographs and composed numerous passages. At this point, I must thank his wife, Sue Ellen Thompson, for all her hard work editing and proofreading this book.

Pat Jessup, also a past president of the museum, is an immensely talented writer and researcher. I thank her most sincerely for contributing her skills to this book. Thank you, Pat.

Lisa Harrington, another past president, graciously donated her father's photographic collection to the museum. Many of Norman Harrington's photographs are included in this book. Thank you, Lisa.

I thank Peggy Morey at Talbot Historical Society (THS) for her help and partnership in collecting and loaning us photographs from their museum's collection.

Lastly, we all thank Leo Nollmeyer, also a past president who has filled many other roles in his 27 years of participation in the museum, including the town's best tour guide. He was our chief fact checker of this book. We thank him for providing insight and advice always.

All images contained in this book are from the collection of the Oxford Museum unless otherwise noted. Several photographs were graciously provided by the Talbot Historical Society and are credited as THS.

Julie Wells
President, 2020–2022
Oxford Museum
Oxford, Maryland

INTRODUCTION

The history and culture of Oxford, Maryland, have been shaped by the water that surrounds it on three sides. The total size is about 250 acres with about 700 residents.

To the east, Oxford is bordered by Town Creek, a small estuary featuring many calm sheltered coves long recognized as ideal for dwellings and waterfront trades. To Oxford's north and west is the Tred Avon River, a deep and protected waterway that flows into the larger Choptank River, which in turn empties into the Chesapeake Bay and, ultimately, the Atlantic Ocean. It was the Tred Avon that established and sustained Oxford as an exceptional British colonial center.

The peninsula's temperate, fertile woodlands, and bountiful local waters supported Native American tribes, including Choptank and Nanticoke people. For generations, they set up their seasonal camps, fished, grew crops, and even buried their dead on this land. The earliest European explorers and settlers came to pursue profit and set up trade. Their first plantations and fledgling communities in the region depended for their survival on the ability to grow tobacco and maintain reliable trade routes to and from Europe.

A place named "Oxford" first appeared on a European map in 1670, although the first known plan for the town dates to 1683. The original arrangement of its streets and building sites, preserved on a parchment map dated 1707, remain nearly unchanged to this day. The primary north-south avenue, originally named ye High Streete (now Morris Street) continues to lead all those arriving in town via the Oxford Road past the most prominent residences and businesses down to the economic heart of the community: the Port of Oxford.

Although it would take decades for a fully functioning village to be established, the harbor quickly became the center of colonial activity. A ferry service across the Tred Avon, still in operation today, was established in 1683. Then, in 1694, the Maryland legislature selected Oxford as one of only two official ports of entry (the other was Annapolis) for British and European vessels to the Maryland Colony. This designation guaranteed that Oxford would remain a hub of commercial activity and collect customs duties on both imported and exported goods.

The first half of the 18th century was a time of increasing prosperity for Oxford. Trading companies from London, Liverpool, and Bristol established "factors" to manage the trade with Oxford and to provide for the export of tobacco, lumber, and wheat from the surrounding plantations. The most important of these traders was Foster Cunliffe & Co. of Liverpool. Its local manager, Robert Morris, became the town's most successful merchant, and his reputation still looms large today. As part of the triangular pattern of trade from Europe to the Caribbean to the American colonies, cargoes poured into Oxford. Arriving vessels off-loaded not only desirable manufactured goods but the British convicts, rebels, indentured servants, and enslaved Africans who were essential to the plantation economy. Col. Jeremiah Banning, a customs officer, described the 1750s scene in his journal: "Oxford streets and Strands were covered by busy crowds ushering in commerce from almost every quarter of the globe. Seven or eight large ships were frequently seen at the same time."

The outbreak of the Revolutionary War marked a swift and devastating end to Oxford's prosperity. On September 11, 1775, the last British ship departed from the harbor. It would be nearly 100 years before the community fully recovered. By the end of the century, Banning lamented, "The once well-worn streets are now grown up in grass, save for a few tracks made by sheep and swine." It was not until after the Civil War that Oxford would fully regain its vitality, and this time it would be based on resources and markets closer to home.

The waters that surrounded Oxford had always offered a rich bounty of oysters, clams, crabs, and fish. By the middle of the 19th century, improvements in harvesting, processing, and transportation led to an explosion of maritime industries. Enormous fleets of tonging and dredging boats hauled in tons of oysters. Black and White laborers filled packinghouses in every cove and harbor, processing the catch for regional consumption and distribution. Steamships arrived in 1823 and carried goods to northern and southern markets by water. And then the new railway into Oxford, established in 1871, provided the speedy transportation required to reach markets across the region and beyond.

Oxford enjoyed an expansion of population, commerce, community services, churches, and schools during the second half of the 19th century. It also became a destination for recreation and tourism, especially as city dwellers from Baltimore and Philadelphia sought to escape to more "salubrious" places. Modest boardinghouses and taverns along the river were improved and expanded into guesthouses and hotels. River View House (1875), Eastford Hall Hotel (1878), Sinclair House (1882), and many others offered their guests water views, bathing, cooling breezes, and fresh food.

Unfortunately, this second wave of prosperity in Oxford was also limited. By the outbreak of World War II, disease and rampant overfishing devastated the Bay's oyster population and brought a slow and painful end to the industry on which the town relied. The packinghouses shut down one after another, their supporting businesses were shuttered, and the community suffered once again.

When America's postwar economic boom revived Oxford's economy, it was not fueled by new industry or businesses. Residents and their elected commissioners decided to build Oxford's future on its traditional culture. They preserved the working waterfront, tree-lined streets, brick sidewalks, and fenced-in yards that had always been part of their town's appeal. The exceptional survival of the village's historical elements earned Oxford its designation as a National Historic District in 2005 and continues to make it an attractive destination for tourists and sailors, as well as a peaceful place to live.

One

OXFORD TAKES SHAPE

Augustine Herrman's map of Virginia and Maryland published in London in 1670 identified a settlement named "Oxford" for the first time, although surrounding lands were being surveyed for future tobacco plantations as early as 1659. The estates of Plimhimmon, Otwell, Anderton, Jena, and Bonfield became the engines of Oxford's progress.

The beginnings of a formal plan for the town date to the Maryland General Assembly's "An Act for the Advancement of Trade" in 1683. Newly elected local commissioners designated a 100-acre tract of land for the village, to be divided into 100 building lots. Ten years later, the General Assembly attempted to make Oxford the capital of the Eastern Shore and renamed it Williamstadt in honor of King William III of England. The plan never took hold, and by 1704, Oxford was again the town's official name. The earliest arrangement of its streets and building sites, preserved on a parchment map dated 1707, remain unchanged to this day. The oldest surviving structures include four houses dating from the mid-to late-18th century: a portion of the Robert Morris Inn, the Barnaby House, a portion of the Stewart House, and Byberry, the only existing 17th-century building.

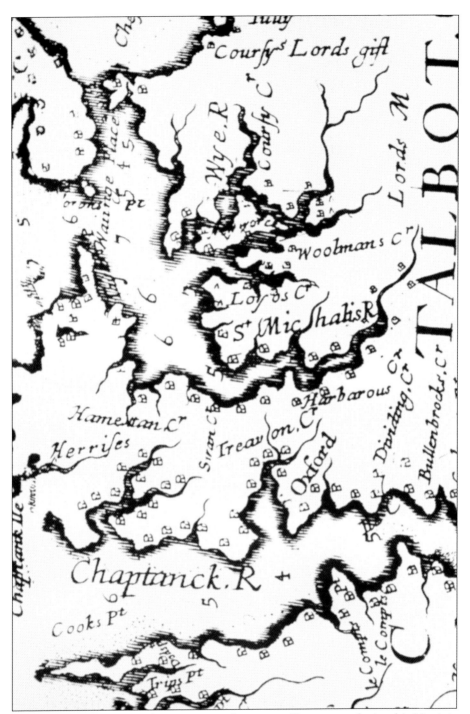

Augustine Herrman, a Prague-born cartographer, spent 10 years producing his Virginia and Maryland map as it is "Planted and Inhabited this present Year 1670." Published in London, it identifies numerous rivers and creeks but notably located only one town, "Oxford," with impressive accuracy on the Chesapeake Bay's Eastern Shore. At the time, Edward Roe's two 30-foot houses might have been all that stood there.

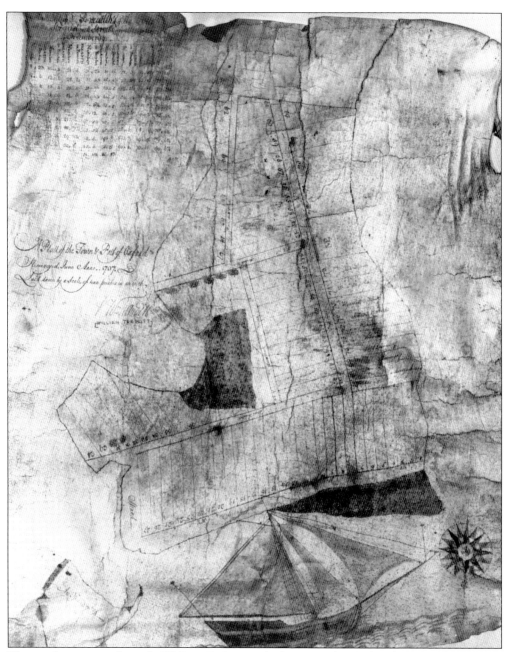

This parchment map, drawn by William Turbutt, is the first map of Oxford and is currently preserved in the collection of the Oxford Museum. Turbutt, the official surveyor for Talbot County, was asked to draw the "plat" in 1707 when Oxford was selected as the location of the county courthouse. In addition to showing the layout of streets, it features one of the earliest representations of a Chesapeake Bay sloop in the lower left corner of the map.

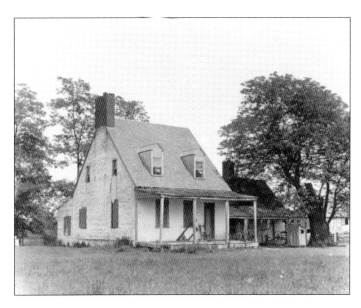

This cottage is believed to be the original Willis farmhouse, built in the late 18th century. At the time this photograph was taken a century later, it appeared to be in disrepair and abandoned. Records indicate that two brothers, John and Philemon Willis, were shipbuilders and storekeepers who moved to Oxford in 1780. The Willis family set down deep roots in the area, operating numerous businesses and farms. Many of their descendants still live in Oxford.

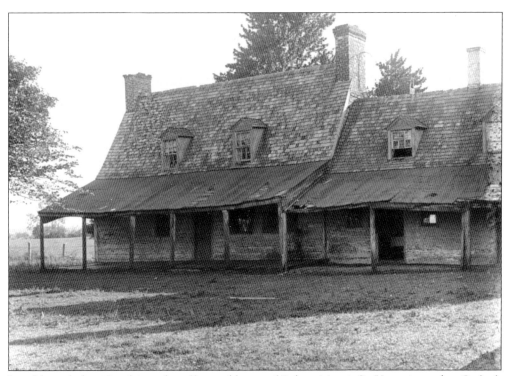

Local legend identifies this as the office and home of Robert Morris Sr. He emigrated to Oxford, where he represented Foster Cunliffe, a trading company from Liverpool, England, from 1738 until his untimely death in 1750. Robert Morris would likely have leased this house from his employer. At the time, it was described as very luxurious, with paintings on the walls, a well-stocked library, and an impressive collection of silver. Some historians believe the house was destroyed by fire. Others think that the surviving sections of the building were incorporated into the River View House, still standing on Morris Street and the Strand but renamed the Robert Morris Inn.

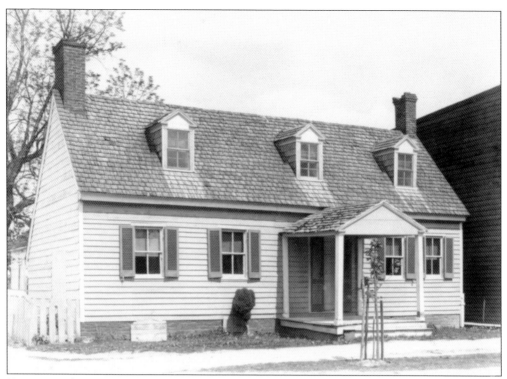

Known as Byberry House, this was originally the residence of the Valliant family. It is the oldest house in Oxford. Built in the late 17th century on High Streete, it was abandoned for years and narrowly escaped demolition. Some reports say it had a mule living in it in the 1930s, when Ralph Wiley paid $250 for it and had it moved five blocks to his new boatyard on Town Creek. In 1963, Wiley sold the yard and the house to Edmond and John Cutts. The Cutts family still owns Byberry. A small store was built on its former site, which, since 2000, has been the location of the Oxford Museum.

Jena was one of the earliest plantations on the Oxford Road. The original house was a small, one-and-a-half-story, yellow brick dwelling built around 1700. This image shows the second house built around 1800 on the existing foundation. The property was named Jena after Napoleon's victory over the Prussians. (Courtesy of THS.)

This is the original 1770s Customs House, located across the Tred Avon River from Oxford on "the Isthmus," Col. Jeremiah Banning's former plantation on Plain Dealing Creek. President Washington appointed Banning the first US collector of customs in 1793. From this vantage point, Banning, then 66 years old, could look across the river and watch for ships loaded with cargo. His duties were to record commerce and collect shipping taxes. The original home no longer exists, but the customs house survives on the property. A replica was built in Oxford in 1976 to commemorate the Bicentennial.

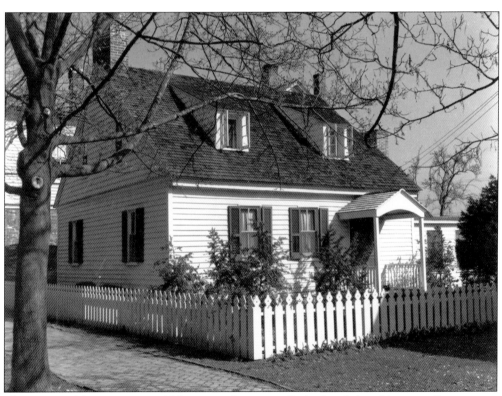

This is one of four remaining 18th-century houses in Oxford and the oldest to still rest on its original foundation. A stone in the basement is carved with the date 1770. The original owner, Capt. Richard Barnaby, set his home perpendicular to the High Streete, unlike every other residence in Oxford. Perhaps he did this to reduce the taxes, which were assessed on a lot's street frontage. The well-preserved interior features a series of carved schooners embellishing the large timber lintel over the kitchen fireplace.

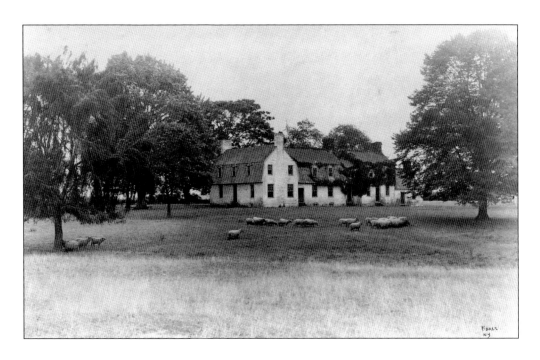

Otwell, a grant of 500 acres, is one of the first Oxford properties surveyed in 1659. The brick house was built in 1662 and owned by William Taylor. It was the site of the county court and was said to be as beautiful inside as it was outside. Originally an important tobacco plantation, it also included a creamery. Over the years, it has sold many times, eventually purchased by the Goldsborough family, who made significant changes and added 250 acres. The Goldsborough family maintained ownership until 1946. It was then abandoned for many years and severely damaged by fire in 1958. Subsequent owners painstakingly restored the property. It remains privately owned today. (Courtesy of THS.)

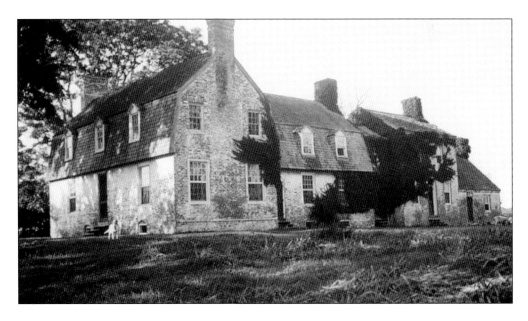

Plimhimmon, also surveyed in 1659, was purchased by Henry Morgan and named for a mountain in Wales. The original parcel was 600 acres, and the house was built on a man-made rise overlooking Town Creek. Over the centuries, the property has passed through the hands of Oxford's most notable families. Matthew Tilghman acquired it in 1787 from Thomas Coward, a wealthy sea captain. Tilghman gave it to his daughter-in-law, Anna Marie, the widow of Lt. Col. Tench Tilghman, aide de camp to George Washington. She lived with her two daughters at Plimhimmon for 55 years. Plimhimmon hosted General Lafayette during his visit to America in 1824. Today, it is a completely restored private residence. (Above, courtesy of THS; below, courtesy of Oxford Museum.)

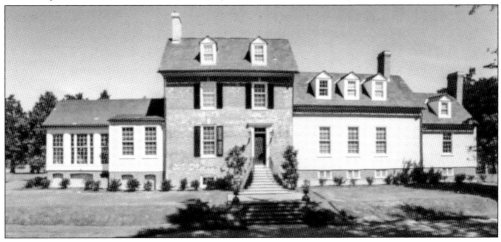

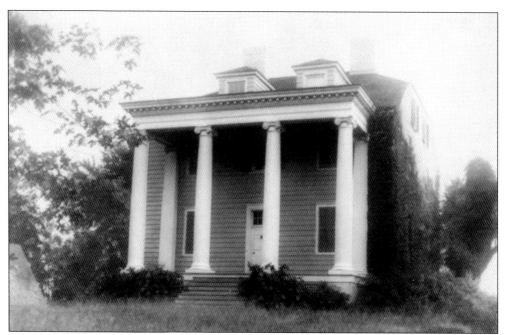

Bonfield was a magnificent home to a very prominent Oxford family. Samuel Chamberlaine Jr. sited his home in 1772 on a rise of land built up by his slaves. Chamberlaine was among the largest slaveholders in the county, with over 130 Africans in his service. When Bonfield burned to the ground on February 14, 1927, it was rebuilt on the same foundation but not in the same configuration.

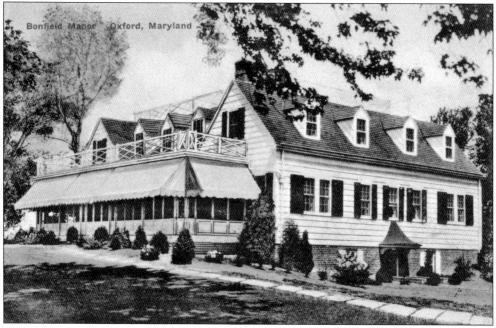

When the rebuilt mansion was opened to visitors as an inn, the 18th-century counting house and office that had survived the fire became the property owner's dwelling. Bonfield is remembered locally for its 1940s owner, Hervey Allen, the author of the best-selling book *Anthony Adverse*. Robert Frost frequently visited Bonfield to write and vacation.

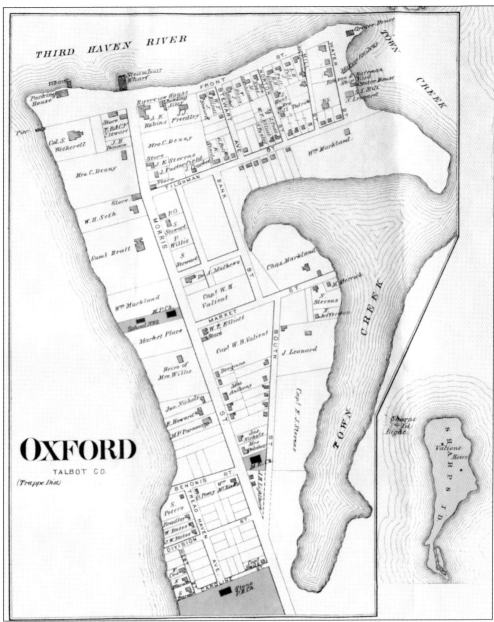

The Sanborn Map Company created maps of cities and towns all across America in the 19th and 20th centuries. They were produced to help fire insurance companies assess their potential liability. This detailed map of Oxford is from their 1877 survey of towns in Talbot County. It shows every residential and business building and empty lot, providing valuable documentation of changes to the town's neighborhoods. Note the bowling alley on the River View House (Robert Morris Inn) property.

Two

GETTING TO OXFORD

During the 17th and most of the 18th century, travel by land through the areas around Oxford was extremely limited, difficult, and dangerous. People and goods could be transported more safely and easily along the rivers and creeks that extended deep into the region, but transport was limited by wind and tide.

After the mid-19th century, sailing sloops and schooners gave way to steam-powered vessels, which were able to navigate without depending on the weather. Steamboats and ferries were soon linked by networks of scheduled routes up and down the Chesapeake Bay to Baltimore and across to Annapolis.

The Maryland & Delaware Railway's service to Oxford, which began in 1871, was even more important. These trains, eventually taken over by the Pennsylvania Railroad system, connected Oxford passengers to important transportation hubs like Philadelphia, carried hundreds of tourists to town, and made it possible for the local seafood packinghouses to ship record-breaking harvests of oysters to market. Regular steamboat service ended in 1932, and the last train left Oxford in 1957. Both fell victim to the rise of automobile and truck ownership and improvements to regional and interstate highways.

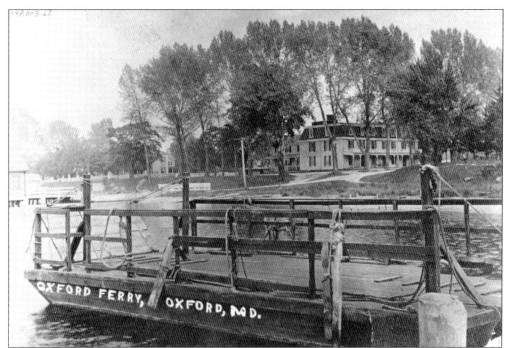

Oxford boasts the oldest continuously operating ferry in the United States. Regular service "for horses and men" across the Tred Avon River was first established in 1683, as the town was just being settled. Operator Richard Royston was paid 2,500 pounds of tobacco a year, which was the legal tender of the day, by Talbot County Court. In this image from around 1890, the ferry is docked at the end of Morris Street, just below the River View House Hotel.

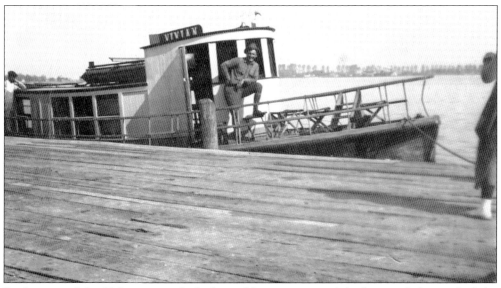

By the turn of the 19th century, the little tug *Vivian* was one of the "engines" that pushed the ferry barge across the Tred Avon between Oxford and Bellevue. Service was provided year-round, carrying horses, oxen, wagons of freight, and passengers in all weather conditions.

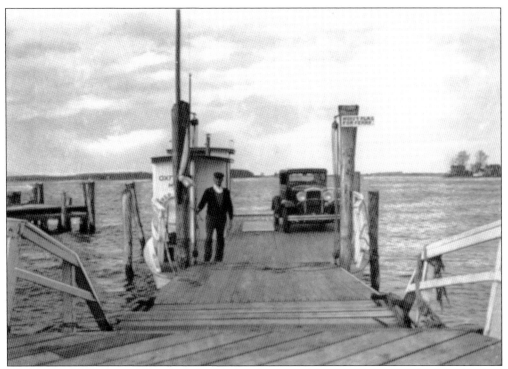

The wooden-hulled *Tred Avon* was Oxford's first self-powered ferry. Built by Capt. Buck Richardson in 1931, she was able to carry at least three of the latest model automobiles with room to spare for passengers on foot. The new ferry made it possible for packinghouse workers in both Oxford and Bellevue to commute daily, and it became an attraction for the tourists who were finding their way to Oxford in growing numbers and wanting a safe boating experience.

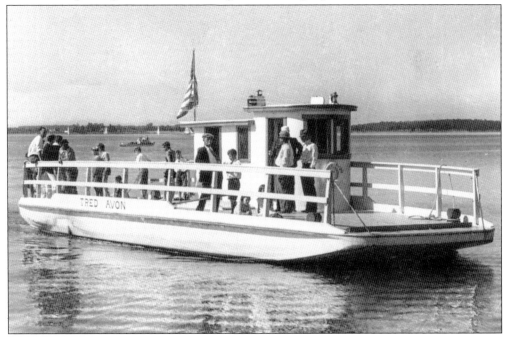

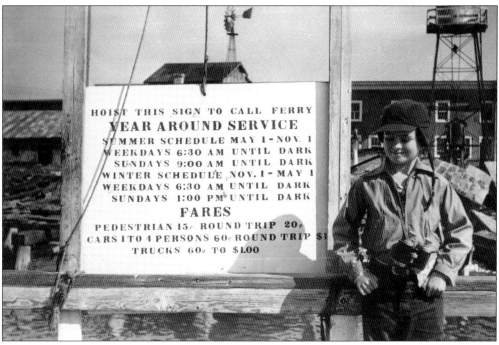

For 350 years, the Oxford-Bellevue Ferry has been privately owned and operated. Unlike ferries in neighboring Delaware, it has never received funding from the state. As a result, the owners have found it necessary to increase fares from time to time to keep up with rising expenses. (Courtesy of THS.)

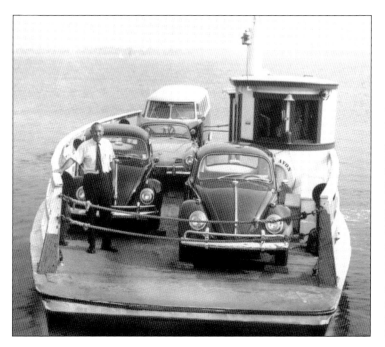

The ferry has long been one of Oxford's great attractions. It has regularly received the attention of journalists and feature writers and has been sought out as a location for advertising campaigns. In the mid-1960s, Fortenbaugh Volkswagen of Easton chose the ferry to show off their latest model Beetle, Bus, and Karmann Ghia.

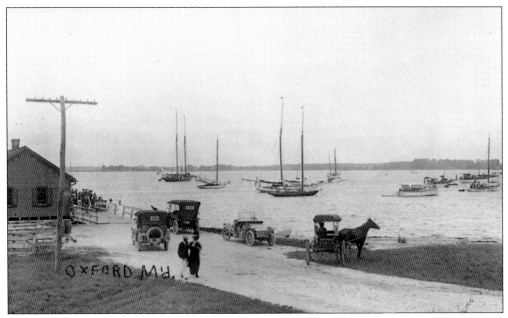

This view shows passengers gathered near Oxford's steamboat wharf at the turn of the 20th century. By the 1880s, both the Maryland Steamboat Company and the Choptank Steamboat Company provided daily scheduled service to get people and freight to and from their destinations. Farmers and "watermen" were able to ship their products to market without delay, and manufactured goods such as tools, building materials, and clothing could be moved easily from cities to rural areas.

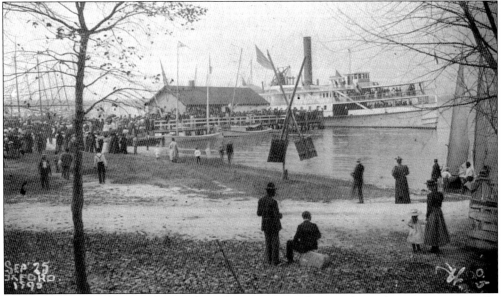

By 1925, when this photograph was taken, there were several types of steamboats operating on the Bay. Large, fast overnight packet steamers carried passengers, freight, and mail between Baltimore and Norfolk. Smaller vessels made multiple stops that linked rural areas of the region, like Oxford, with the big cities. And comfortable excursion steamers like this one carried passengers to the many resort destinations that flourished on the Bay. Notice the tall smokestack for her steam engine and protruding walking beam.

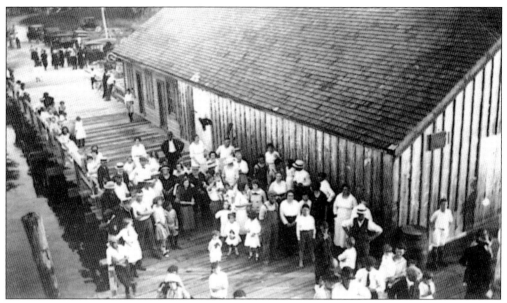

This photograph was taken from the deck of one of the steamers in the 1920s and shows the size of the crowd that would gather at the Oxford wharf to greet arriving passengers or wait to board. These steamships were the most popular way to travel around the Bay for many decades, but it was not long before Marylanders preferred to drive themselves around the region in their new automobiles. Regularly scheduled steamboat service to Oxford ended in 1932, twenty years before the opening of the Chesapeake Bay Bridge.

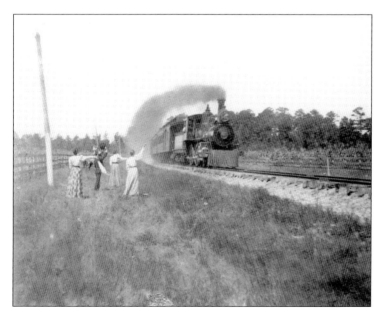

The establishment of railway service to Oxford in 1871 was cause for real celebration. It had been the long-held dream of General Tench Tilghman to connect Oxford residents and businesses to a wider world of possibilities. The Maryland and Delaware Railroad Company offered daily passenger and freight service to Easton and beyond, departing daily at 7:00 a.m. and 1:00 p.m.

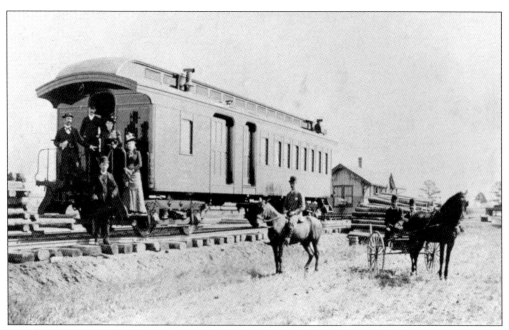

Regular train service to Oxford ushered in an era of transformation. Where travel by land to Easton, Philadelphia, and beyond had required long and difficult journeys by horse and wagon, people and produce (especially oysters) could now be transported comfortably and without delay. The Pennsylvania Railroad added the Oxford line to its network in 1882 and continued to operate passenger trains until 1949 and freight service until 1950. Once freight service ceased, products were delivered by truck until 1957. In the image below, engineer Mr. Boggs and fireman Mr. Argo pose proudly in front of engine 6510 at the Pier Street terminal.

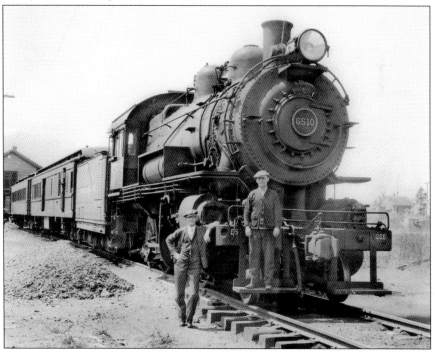

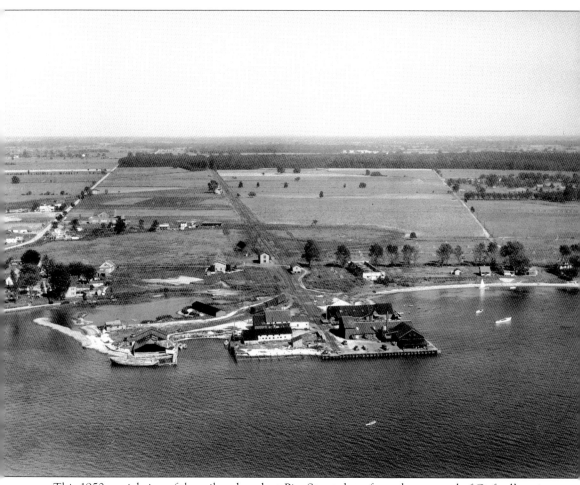

This 1950s aerial view of the railroad yards at Pier Street dates from the very end of Oxford's train service. At the turn of the 20th century, this area was as close as Oxford would come to having an industrial center. The few seafood facilities visible on the shore of the Tred Avon River are all that remain of the once bustling Valliant's, Seth's, McKenzie's, Gallup's, Leonard's, Spears & Pope's, Kirby's, and Jones's packinghouses.

Three

OXFORD AT HOME

Oxford's population, demographics, and commercial activities have changed dramatically since these early 20th-century photographs were taken, yet many of the 19th-century homes and public buildings, and even a few from the 18th century, still stand today.

Much credit for the preservation of Oxford's historic neighborhoods is owed to the town's 2005 decision to establish a historic district. The historic district was primarily defined by tree-lined streetscapes, brick sidewalks, fenced-in yards, and frame dwellings erected between 1875 and 1910.

These were the town's boom years, when the population swelled from 300 to more than 1,200 full-time residents, half of whom were Black and half of whom were White. This also coincided with the widespread use of cameras and the growing popularity of photography. Ironically, the survival of so many of the homes pictured here is also due to a failing regional economy. When the local seafood industries collapsed in the 1950s, so did property values in Oxford and across the eastern shore. The quiet town at the end of a rural peninsula, far from the nearest highway, escaped the attention of most commercial developers, thus sparing Oxford from the impact of 20th-century "renewal."

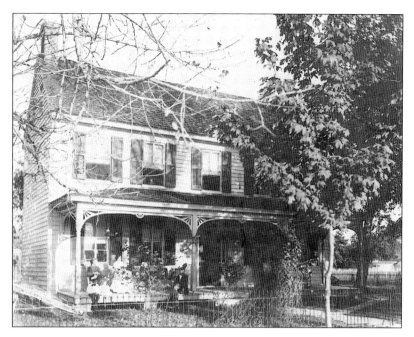

This is the Pastorfield-Valliant House, built on Morris Street in 1870 by John and Anna Pastorfield. It was purchased by Jeremiah Valliant in 1898 for $1,616. He was part owner of an oyster packinghouse. The two small children on the porch are Robert T. Valliant and Louise Valliant Willis.

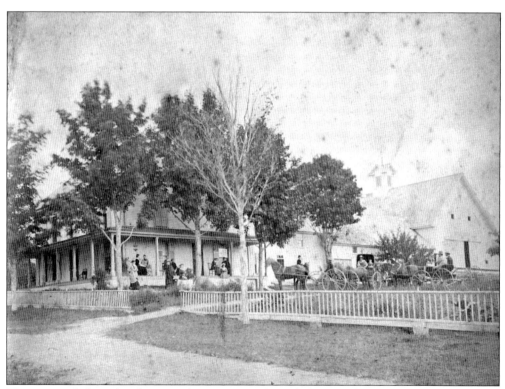

This image of a large farmhouse with a wraparound porch, barn, and outbuildings was taken just beyond Oxford's village center. Sixteen well-dressed people have positioned themselves on the porch and the lawn, while others rest in buggies and wagons. Posing for a family photograph was a major occasion.

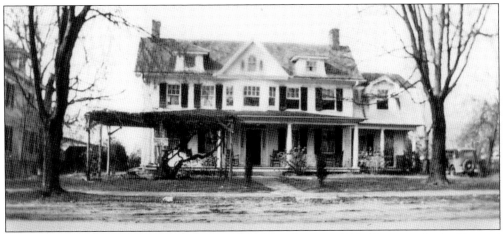

John Willis came to Oxford in 1780 and built this residence in 1798. He was a shipbuilder and a storekeeper at a time when few stores remained open. Willis would become Oxford's Customs Officer in 1804. His brother William, a clipper ship captain, brought a grapevine plant back to Oxford from the Isle of Jersey in 1810 and planted it at the house. The vine grew to such proportions that it became a tourist destination for over a century. The original vine remains today, although the house has changed significantly over the years.

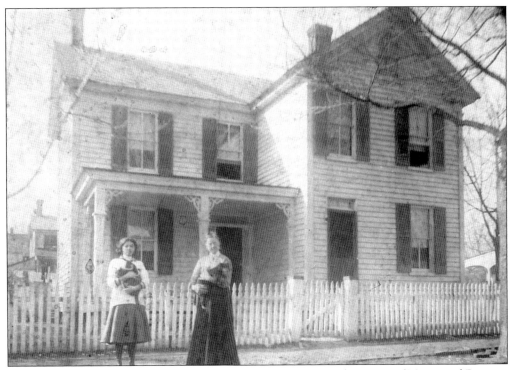

Two women pose in front of the Mary Kinney Hopkins house on the corner of Morris and Division Streets. Open porches facing front and picket fences were common elements of many Oxford houses, but the real subject of this photograph seems to be the ladies' pets.

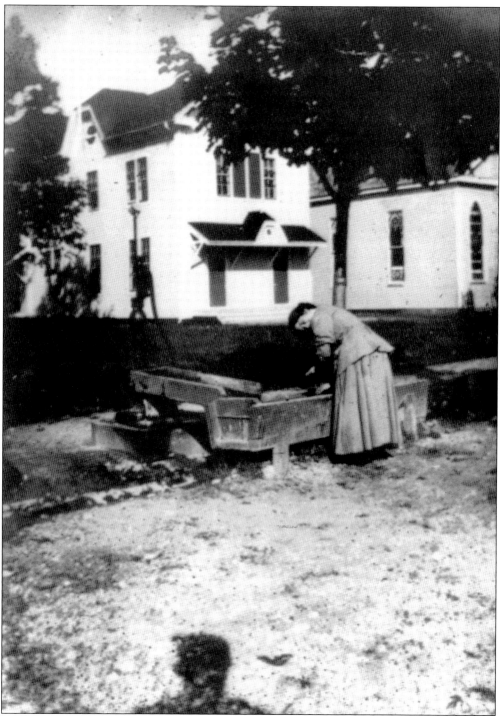

This is an exceptional photograph of everyday life in Oxford. Eunice Parsons Highly is captured bending over the water trough at the town well in the park. In the background to the right is a glimpse of the town schoolhouses and the Methodist church, while the photographer's shadow can be seen in the foreground.

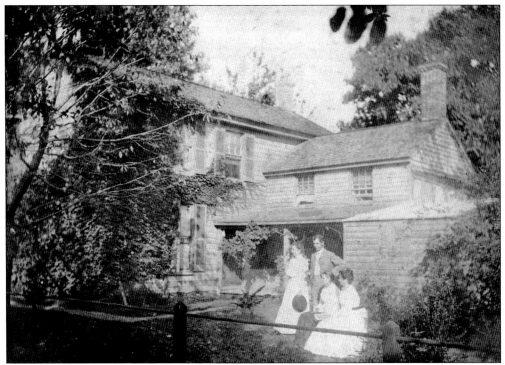

These two images show members of the Anthony family in the yard of their home on Morris Street. They were very active members of the community, and Lucretia Anthony was a beloved schoolteacher known as "Miss Lu." She was a principal and taught elementary school for over 40 years, beginning in 1875. The image above includes not only Anthony family members, but their Black servant and two young barefoot boys looking directly at the camera.

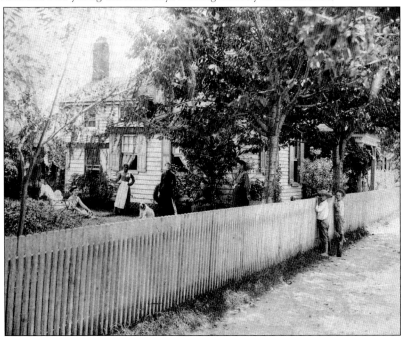

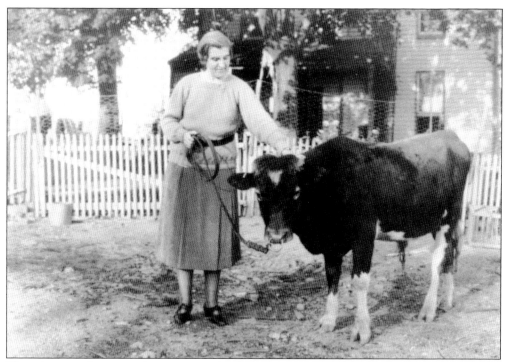

This photograph appeared on a 1936 calendar. It features a bull named Bill and his handler, Virginia, in front of a house in Oxford. It was not unusual then for homeowners to keep dogs, chickens, and other small animals in town, but even bulls were not a surprise.

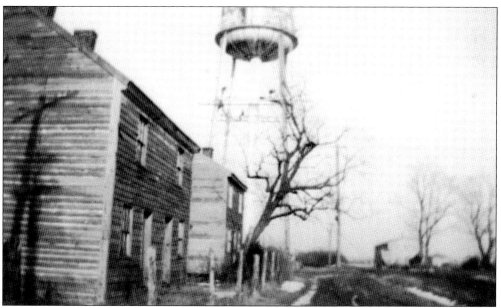

This is a view looking east down Tilghman Street near Mill Street, in the heart of Oxford's Black neighborhood. The first house on the left belonged to Ernest "Hump" Banks and the second to Hattie Brown. At the end of Tilghman Street was the Oxford Seafood Company. The town's water tower has stood in this location since the mid-19th century.

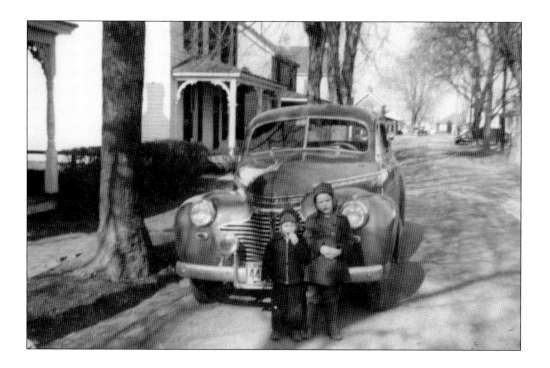

At the end of the 20th century. Oxford did not have enough children to keep their school open, but 50 years earlier, the village was filled with growing families. Above, brothers Tim (left) and Tom Fluharty pose on a cold day in front of their father's 1940 Chevy Special Deluxe on Morris Street. Was it the boys or the shiny automobile that caught the photographer's eye? Below, two girls are taking their dolls for a ride along Oxford's quiet streets. They have stopped for a photograph in front of the town's general store.

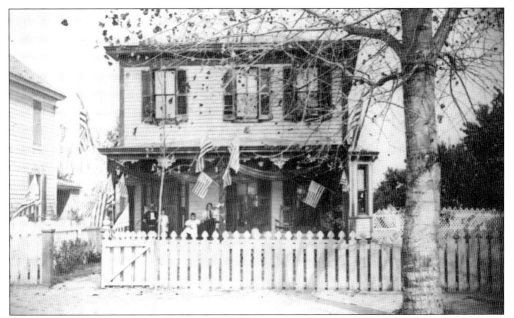

Built in the 1880s, this was the Morris Street home of local decoy artist and grocer Ed Parsons and his family. It appears to be decorated for the Fourth of July. The Parsons' store, just a few blocks away on Morris Street, burned down in 1932—a blaze that destroyed neighboring buildings as well. Luckily, Ed's shop behind the store survived, so he could continue to carve his decoys, which were in great demand. In one transaction, he sold 300 to automotive pioneer Walter Chrysler, who would entertain his friends at his hunting lodge on the Choptank River.

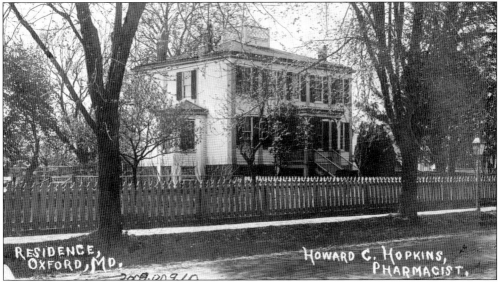

The Academy House, or the Bratt Mansion, is one of Oxford's grandest residences. Erected around 1848 by Gen. Tench Tilghman, the building served as home for the faculty of his short-lived Maryland Military Academy. It was purchased in 1862 by Henry and Jane Bell of Ireland, who soon made a wedding gift of it to their daughter Mary Ann on her marriage to Samuel Bratt of Baltimore. The Bratt family maintained their ownership for over a century. The Academy House remains a private residence today.

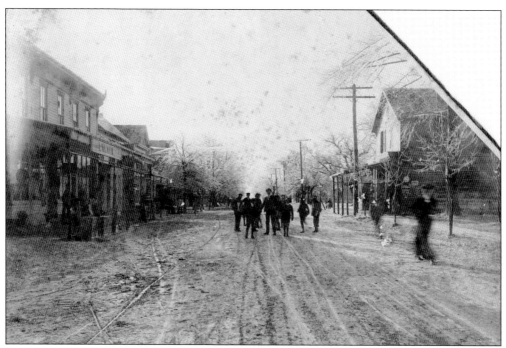

Snow was enough of a rarity in Oxford that the photographer of these two images made a special effort to capture the scene. Walking from the harbor up Morris Street, he records the crowd gathered at the center of town (above); then, turning back, he found only wagon tracks and foot and hoof prints on the slushy road. The utility poles were recently erected, bringing telephone service to the community.

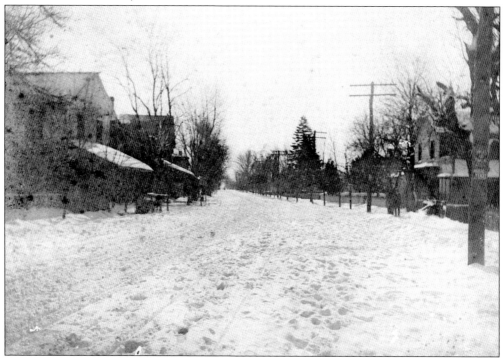

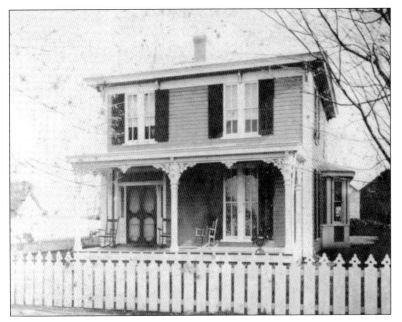

This house was built in 1876 by Dr. A. Matthews. It was here that he raised his family, and it later became the home of his son Spencer. Note the Oxford picket fence and rocking chairs on the front porch. In the 20th century, this house would become the 1876 Bed and Breakfast Inn and then the Ruffled Duck Bed and Breakfast. It is now a private residence.

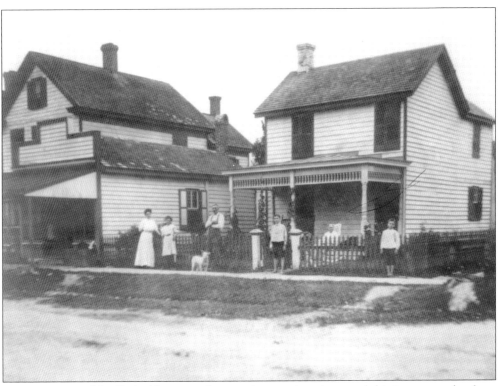

It was not unusual for Oxford houses to be moved to new locations, and this is an example of one such move. These two houses were located on Morris Street. The one on the right belonged to William McKenzie, whose family is pictured out front. That house was moved around the corner to Benoni Street in 1920, and the small building to its left was moved to the vacated lot.

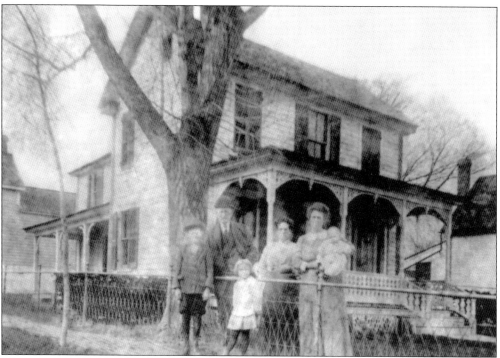

Above is the home of John and Julia Faulkner at 410 S. Morris Street. Pictured in front of the house are the Faulkners with their daughter Mary Ellen Howeth and her children John, Anna, and baby Robert. This was John's "second home." He was also the keeper of the Benoni Point Lighthouse. Mary Ellen did not move far away from her parents. Below is the Howeths' home, right next door at 408 S. Morris Street.

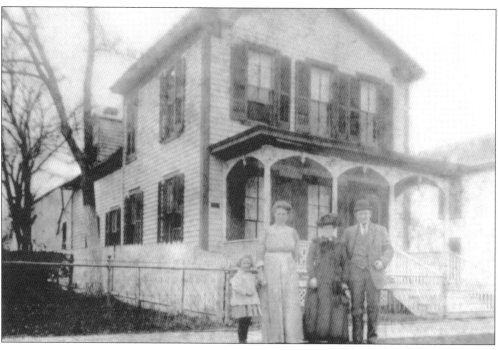

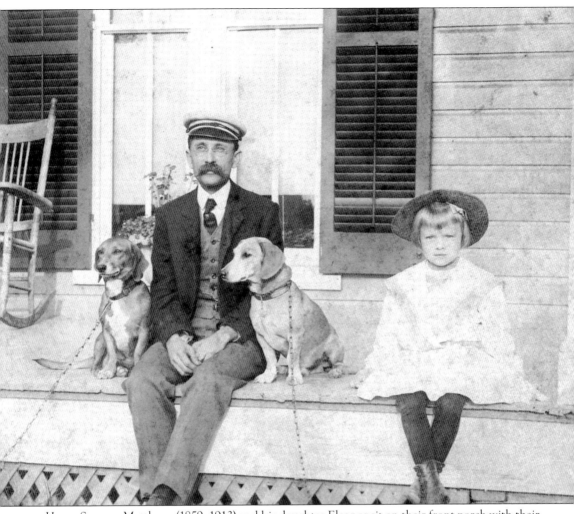

Henry Spencer Matthews (1859–1913) and his daughter Eleanor sit on their front porch with their two dogs. Henry was one of the town's two pharmacists.

The only one of its kind in Oxford, this two-story brick townhouse stands at 200 Tred Avon Avenue. Built as a "spec house" around 1885 by the Bergman Brick Company, it was patterned after the urban rowhouses in Baltimore. It was Bergman's plan to build several more down the block, but that never happened. Bergman Brick Company produced many of the bricks used in the sidewalks along North and South Morris Streets, which are stamped with the letter B. This house later became the home of John and Betty Moll. John was a prolific artist, and Betty was one of the original founders of the Oxford Museum.

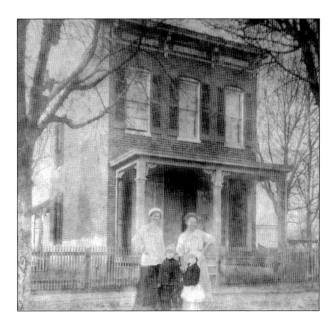

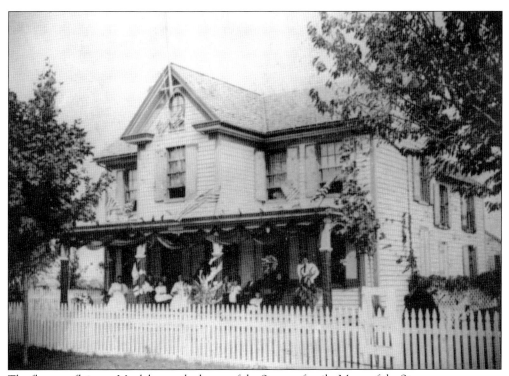

The flags are flying at Maplehurst, the home of the Stevens family. Many of the Stevens women were teachers in Oxford's schools. Nannie Stevens taught first grade, and Nellie Stevens was the high school principal. Nellie was also keenly interested in botany. She experimented at her home with the cross-pollination of a Chinese holly and the native holly tree. The seedlings thrived and were registered in 1952 as the Nellie R. Stevens Holly. They can be seen in many Oxford gardens today.

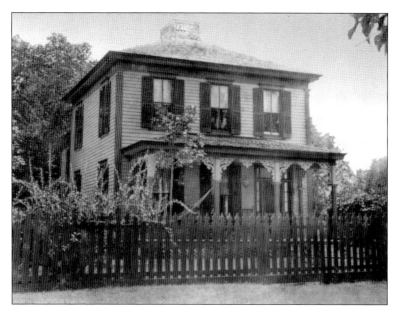

This is the John J. Freedley House, 104 Strand, built in 1874. The elegant mansard-roofed structure is located high on the Strand and enjoys beautiful views westward of the Tred Avon River. Historical records indicate that the owners of this house once kept cows in the backyard. The house is still a private residence, but the cattle have gone.

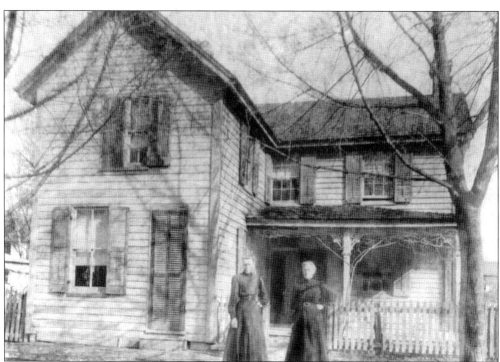

The two women in this picture are unknown, but judging by their attire, this photograph must have been taken in the late 1880s. The house was known as the Henry E. Bateman house on South Morris Street and was built around 1877. Bateman was a boatbuilder, and his boatyard on Town Creek became the Oxford Boatyard.

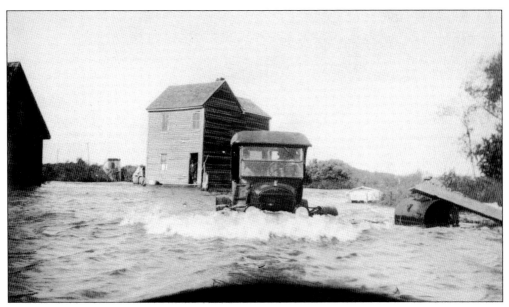

The village of Oxford is surrounded by creeks and rivers, and much of it lies on very low ground. Its residents have always been affected by storm surges and tidal flooding and will certainly continue to be. The driver of this Model T (above) is trying to get through the flooded streets, or perhaps he's just testing his courage for the waiting photographer. A school bus can be seen plowing through a high tide (below) on Tilghman Street. Thankfully, this scene is not repeated often.

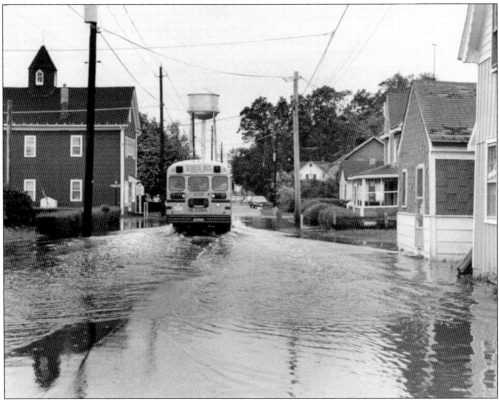

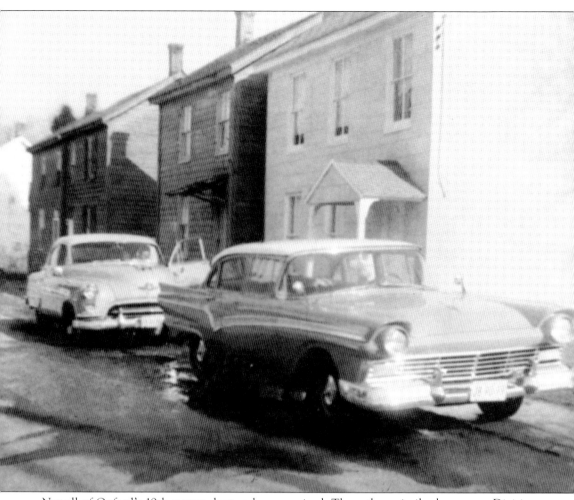

Not all of Oxford's 19th-century houses have survived. These three similar houses on Division Street were put up quickly during the oyster and railroad booms. Pictured here with some classic automobiles from the 1950s, the houses had already fallen into disrepair. All three have since been torn down.

Four

OXFORD AT SCHOOL

Oxford's first public school was a very small building that was moved to the north side of the town park in 1868. It was quickly outgrown. The Talbot County School Board authorized a second, larger building on the same site in 1872. These primary and secondary schools served Oxford's White children until 1928, when a new school building was constructed out on the Oxford Road.

During the second half of the 19th century, Oxford also hosted two military academies. West Point graduate Gen. Tench Tilghman founded the Maryland Military Academy in 1847 on land near the town park. The curriculum was focused on the training of young men in the "Southern tradition." The school was forced to close in 1855 after a fire destroyed the students' facilities. A second Maryland Military and Naval Academy was launched in 1885 by Tench's son Col. Oswald Tilghman, who had served in the Confederate army, but the school lasted only three years.

Oxford's growing Black community built its own school at Tilghman and Stewart Streets after the Civil War to provide basic instruction for grades one through eight. But there was nowhere in Oxford or Talbot County for a Black child to progress beyond the eighth grade until the first Black high school was opened in Easton in 1937.

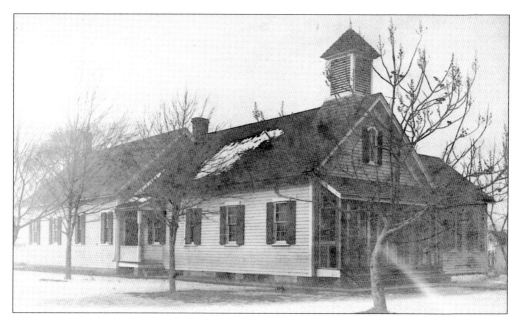

Pictured above is Oxford's first elementary school. It was housed in a building that had been moved from the outskirts of the village to the town park in 1868 and then modified to provide classrooms for students. By the 1870s, the building was outgrown, and a new high school was built adjacent to it. The below photograph from 1894 shows both Oxford's elementary school and the new high school. In addition to the students assembled, there are several newly planted trees. Today, the school buildings are gone, but these same trees dominate the park.

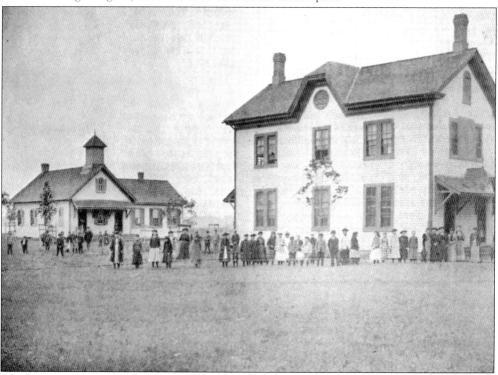

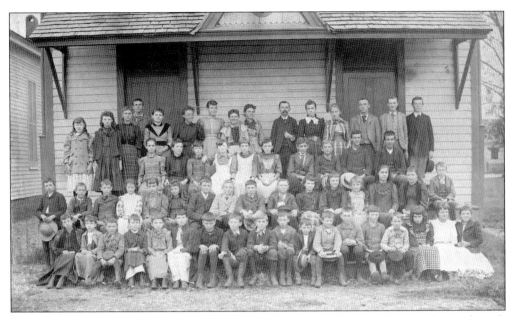

This image shows the students attending the Oxford Elementary School in 1892. Grades one through eight are gathered and somehow kept from squirming long enough to allow the photographer to do his job. At the time, Oxford schools were segregated. Black students were required to attend their own school. In 1928, when a new school was built on the Oxford Road, this building in the park was torn down.

Here are the members of the Oxford High School graduating class of 1906. From left to right are (first row) Alex Willis, Margaret Parsons, and Kane Valliant; (second row) Suzy Smith, Mattie English, Albert Stewart, and Myrtle Thompson; (third row) Addison Cox and Phil Willis.

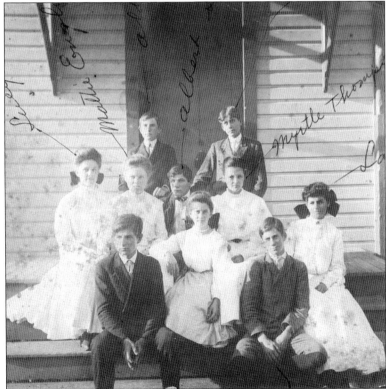

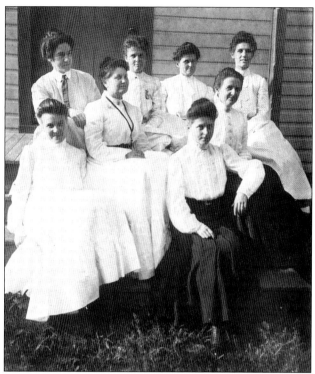

This 1909 photograph shows all the Oxford Grade School teachers. From left to right are (first row) Erma Stewart and Myra Gibson; (second row) Lucretia "Miss Lu" Anthony, and Nannie Stevens; (third row) Miss Bouldin, Nellie Stevens, Mamie Jackson, and Ella Smith. Most were spinsters, as married women at that time were not allowed to be teachers.

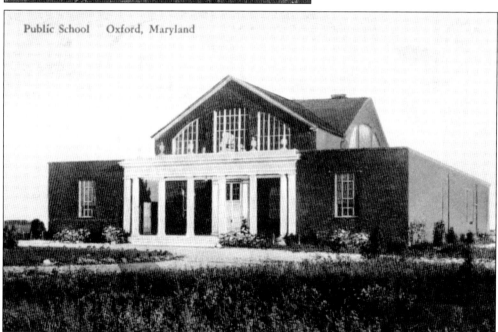

Public School Oxford, Maryland

Both elementary and high school classes moved to the new Oxford School in 1928. Ten years later, junior and senior high school students were assigned to Easton High School, necessitating an 11-mile bus ride each way. Oxford's elementary school remained in this building. In 1956, the Oxford school became the only school on the Eastern Shore to admit selected Black pupils. It was not until 1966 that all Talbot County schools were fully integrated.

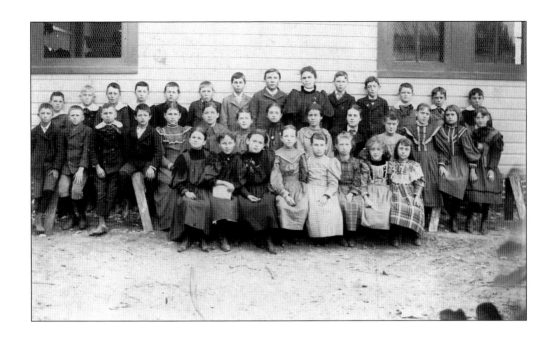

As Oxford's population grew rapidly, the number of students attending the elementary school increased as well. These two images from around 1890 (above) and around 1915 (below) both show well-dressed students but reveal the changing fashions around the turn of the century.

Rules and Regulations

of the

OXFORD HIGH SCHOOL.

PRINCIPAL.

1. The Principal, by virtue of his office, shall be at the head of the school. He shall act under the advice and direction of the School Board and of the Superintendent.

2. The Principal shall seek the cooperation of the assistant teachers; and shall support them in the exercise of their various duties. He shall when called upon, advise them and make suggestions with reference to their course of instruction and discipline in their respective grades.

TEACHERS.

1. The assistant teachers shall cooperate with the Principal in the management of the school and shall act under his directions.

2. Each teacher shall be held responsible for the instruction and for the discipline of her own class.

3. Teachers shall be in their respective school-rooms thirty minutes after eight in the morning, and at twenty minutes past one o'clock in the afternoon. They shall see that their rooms are open at twenty-five minutes before nine o'clock for the admission of pupils. They shall require all who are in the room to observe the rules of order.

4. Teachers shall be firm in their discipline. They shall insist on instant obedience, and shall not tolerate insolence in any degree.

5. Teachers shall not allow the pupils to remain in the building after the close of school unless they remain with them.

PUPILS.

1. All pupils who are not willing to submit cheerfully to the rules and regulations of the school and to obey the teachers shall be dismissed.

2. Any pupil guilty of willfully cutting, marking, or defacing the school building, desks, walls, fences, or other school property, shall be punished by suspension.

3. Pupils guilty of using tobacco in any form or profane or obscene language on the school premises or within a radius, of two hundred yards of the school, shall be suspended.

4. After school hours, unless detained by a teacher, no pupil shall remain on the school premises or in the immediate vicinity of the school.

5. No pupil, except those coming from the country, shall be admitted to the building before thirty minutes after eight o'clock in the morning. The teacher may, however, admit any pupil to his or her room for study, or for some other reason, before this time provided that the teacher, also, remains in the room.

6. In the building and on the school grounds the pupils must be orderly and courteous to one another and to persons passing by.

7. Pupils, in passing to the recitations, in going out of the building, in moving up and down stairs shall preserve proper order.

8. In all matters, pupils are enjoined to be respectful and earnest in their work, and to cooperate with the teachers in order that they may receive the great benefit from the school.

By order of the School Board.

M. B. NICHOLS, President.

This instructional poster of Oxford High School's rules and regulations provides a glimpse into the behaviors expected of both students and faculty a century ago.

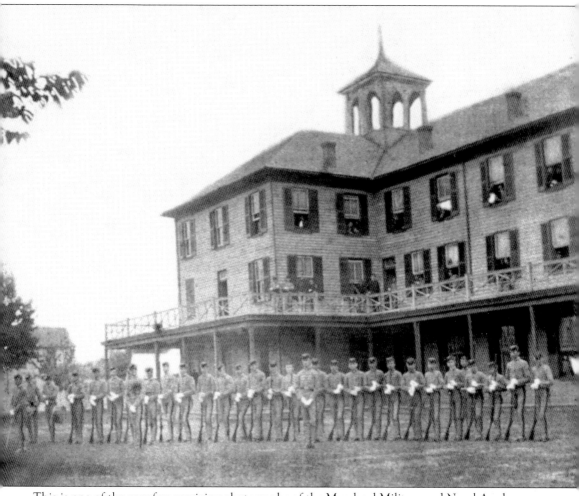

This is one of the very few surviving photographs of the Maryland Military and Naval Academy. Standing in front of the building are 30 cadets, with many more waving from the windows behind them. The large building was purchased by Col. Oswald Tilghman from the Eastford Hall Hotel when it went bankrupt in 1884. The academy lasted just three years, and then the hotel took possession again. Unfortunately, after the building caught fire in 1894, all that remained was a small, white building close to Morris Street that became a store.

MARYLAND MILITARY AND NAVAL ACADEMY,

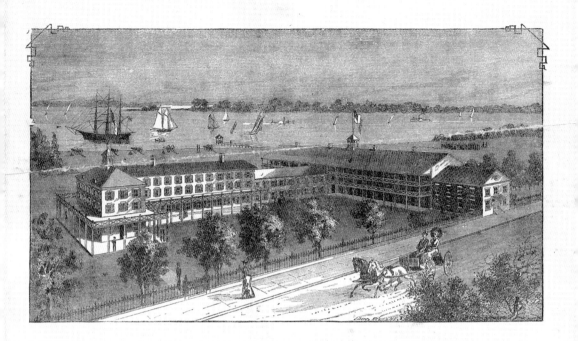

OXFORD, MD.

This engraving presents an imaginary bird's-eye view of Oxford's Maryland Military and Naval Academy in its park setting. Notice that the school's training ship *Amazon* is shown in the background, among other sailing craft on the Tred Avon River, while an oversized carriage makes its way up Morris Street.

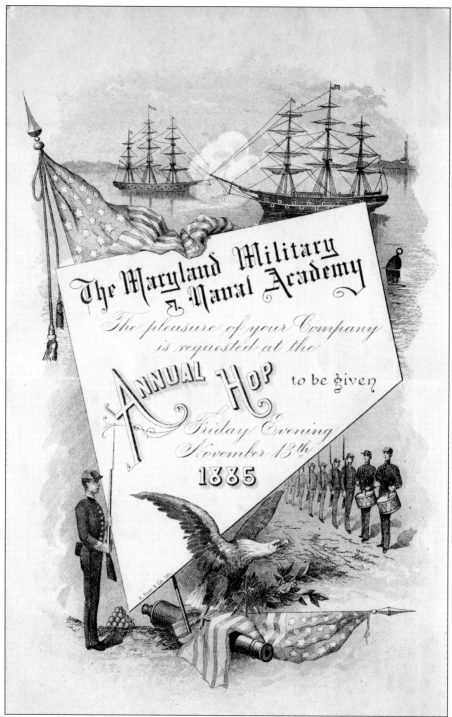

Col. Oswald Tilghman knew the importance of socializing to the cadets of his Maryland Military and Naval Academy. Events such as the annual hop in 1885 were meant to maintain morale. The academy, with its 17-member faculty, saw enrollment rise to over 250 in 1886, then plummet to just 30 in 1887 when the students revolted against their rigorous training and the administration's incompetence.

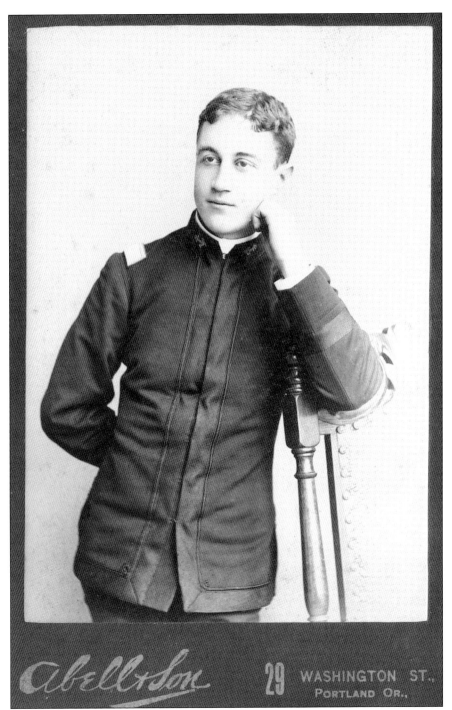

Abell & Son 29 WASHINGTON ST.,
PORTLAND OR.,

School photographs are nothing new, but in the 19th century, they were beautifully mounted on cards as "cabinet photographs" that promoted the photographer as well. These studio portraits show two of the young cadets who attended the Maryland Military and Naval Academy between 1885 and 1888. Above, Cadet G.L. Abell came to Oxford from his home in Portland, Oregon, where his family owned a photographic studio.

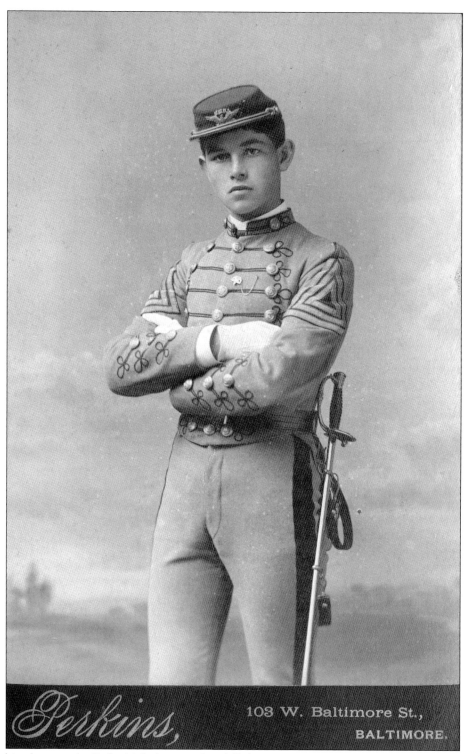

In this photograph, Cadet McIndoe posed in full dress uniform with a sword in the studio of a Baltimore photographer.

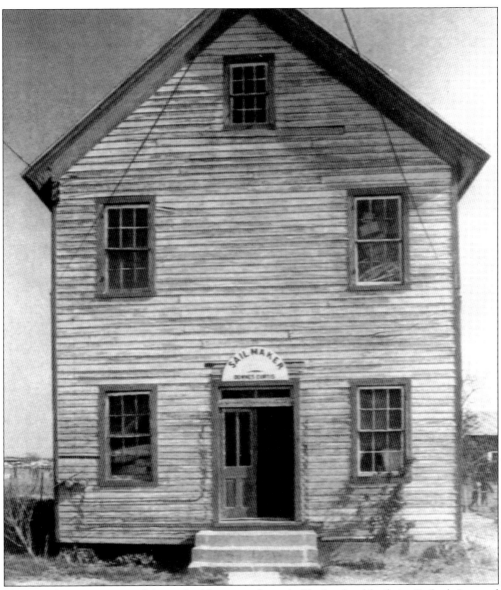

This simple two-story wood frame building was the only Black school built in Oxford. Located on Tilghman Street in the heart of the town's African American neighborhood, it held classes for grades one through eight only. Once larger segregated schools in neighboring communities were made available to Oxford's Black students, the school was closed. The building was later used as a sail loft by brothers Downes and Albert Curtis and has since been restored as a private residence.

Five

WORKING ON THE WATER

When trade with Britain and the rest of Europe ended suddenly after the Revolutionary War, Oxford's economy fell into a depression that would last nearly a century. The town's population dwindled, and the plantations that had produced the most valuable exports now had few markets for their goods.

It was Oxford's watermen who led the way to the community's recovery. The bounty of the local waters, and above all oysters, fueled the town's renewal. The abundance of oysters in Oxford's waters and along the Chesapeake Bay had always been recognized, but after the Civil War, the harvesting and processing of oysters became industrialized. Investment in new boats and harbor facilities, along with the ability to transport perishable cargo directly from Oxford by railroad, made all the difference. In 1865, a total of 4.8 million bushels of oysters were shipped from the Chesapeake Bay; by 1885, the harvest was over 15 million barrels. By 1890, at least nine packinghouses were operating in Oxford, employing hundreds of Black and White men and women to shuck oysters in the winter and pick crabmeat in the summer. When the oyster boom finally ended after World War II and the last of the packinghouses closed, local boatyards and marine trades managed to survive by refocusing their attention on the needs of recreational boaters.

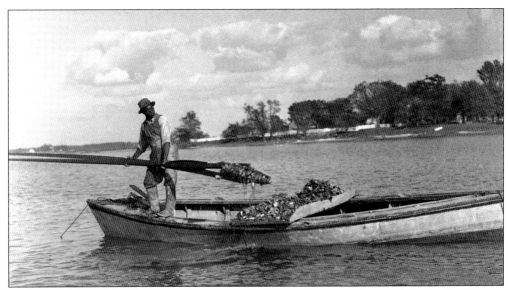

Tonging for oysters was common practice in the sheltered waters of rivers like the Tred Avon. It required only the most basic equipment: a boat and a set of tongs. By 1880, more than 450 watermen, both Black and White, were issued tonging licenses in Talbot County. Working alone or in pairs from a log canoe or flat-bottomed work boat, the watermen would lower their tongs, 15–20 feet long, to the bottom and, after repeated pinching motions, raise the collected oysters to the culling board on deck for sorting. It was backbreaking work during the coldest season of the year—note the blanket of snow on the Strand. (Both, courtesy of THS.)

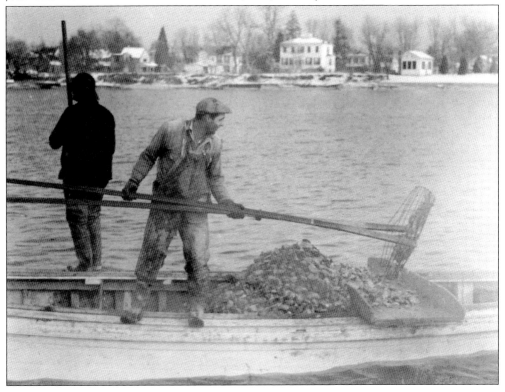

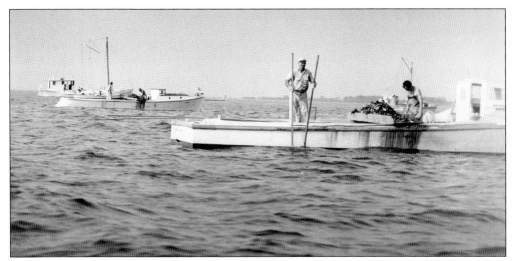

This view shows the crews of two motorized tonging boats working on an unusually warm, calm day. In the background is a "buyboat," a larger motorized boat that would patrol the oyster grounds, collecting the catch from the smaller boats and delivering it to the packinghouses, which might be as near as Oxford or as far away as Baltimore.

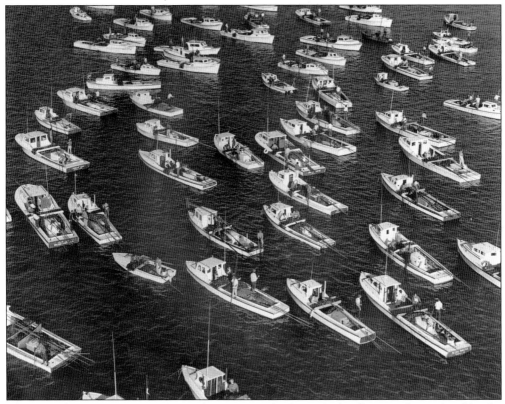

The oyster harvesting season—September 1 to April 15—was and still is strictly regulated by the State of Maryland. On opening day each winter, every available tonging boat would head to the most promising oyster reefs to begin the season's work. This was the scene on the Choptank River on opening day in about 1950.

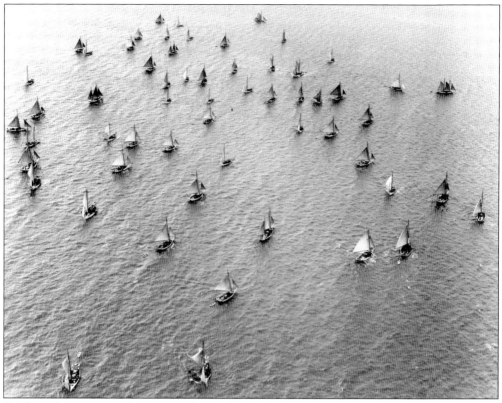

Dredging for oysters was far more productive than tonging for them. The Chesapeake Bay "skipjack" was a single-masted sailing vessel specifically designed and built to pull an iron oyster dredge. Every harbor around the Bay had its fleet of skipjacks; there were over 3,300 working the oyster reefs in 1885, which helps account for the overfishing that ultimately brought the important industry to an end.

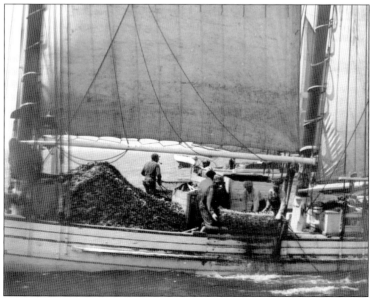

Rules required that dredging could only be done under sail, not power. A crew of five or six watermen would be required to manage the sails of a skipjack or a two-masted "bugeye" schooner like this one and haul the heavy dredge up to the deck.

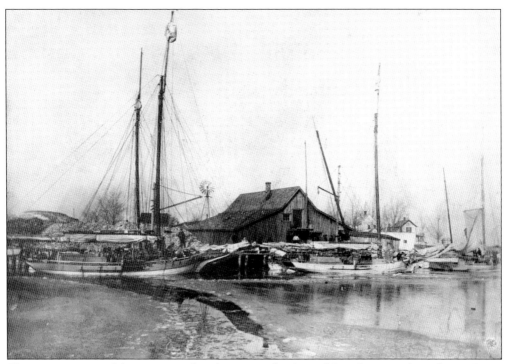

These two scenes of the oyster packinghouses at the foot of Pier Street and on the icy Town Creek begin to suggest the scale of this industry. Between 1875 and 1969, there were at least 24 packinghouses in Oxford. Above, five tall masts indicate five skipjacks unloading at the docks on the same day. The shorter slanted pole is a hoist for lifting the heavy catch onto land. Below, smaller tonging boats are tied up dockside as watermen gather to compare or complain about their harvests. Notice the mountains of oyster shells covered with fresh snow in the background. The empty shells were sold as paving material or returned to the river as habitat for young oysters. At the height of the industry, over 250 people worked at Pier Street businesses.

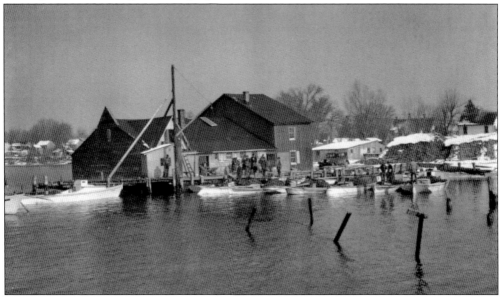

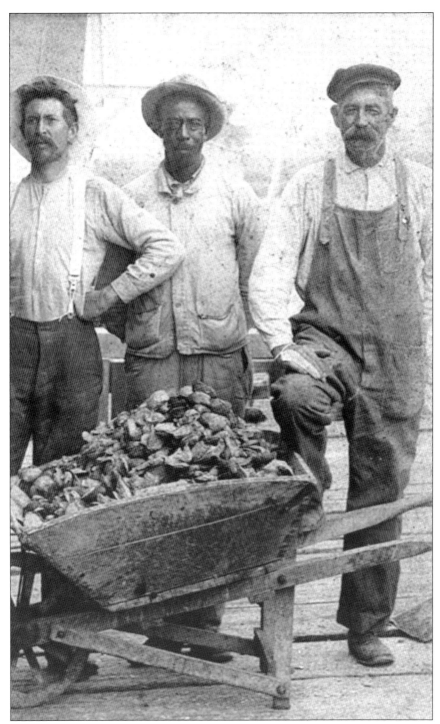

Once the oysters were offloaded directly from the sailing bugeye schooners, the skipjacks, or the powered buyboats that collected the haul out on the water, were moved from dockside to the shucking house. Teams of men worked the docks, transporting the catch by wagon or wheelbarrow to the shucking tables inside.

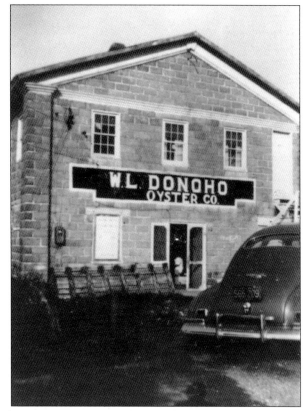

Donoho's Packinghouse was one of the dozens of establishments that blossomed along Town Creek and at the end of Pier Street due to the rapid growth of the oyster and crab business in Oxford. This building has a long history. Located at the end of Tilghman Street, adjacent to the Oxford Boatyard on Town Creek, it was first W.L. Donoho Oyster Company in the 1920s and 1930s, then Oxford Packing Co. in the 1950s and 1960s, followed by Oxford Carry Out in the 1960s and 1970s, then the Tred Avon Restaurant in the 1970s and 1980s, Schooners Landing Restaurant in the 1990s and 2000s, and most recently, Capsize Restaurant.

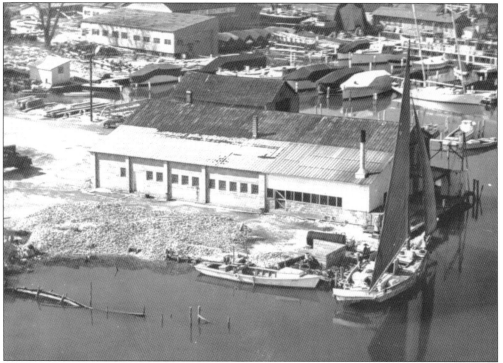

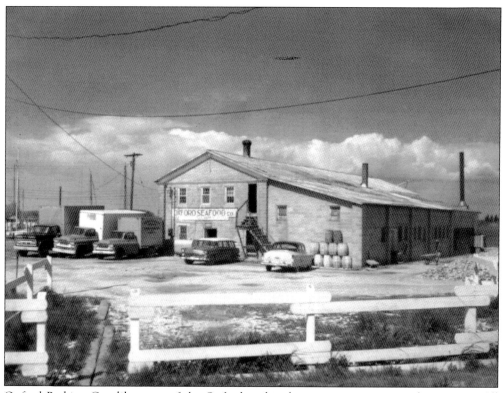

Oxford Packing Co., like most of the Oxford packinghouses, was a year-round operation. All winter it processed oysters for shipment across the country and around the world. Then, during the summer and fall, it transitioned to the steaming, picking, and canning of crab meat. This 1960s scene shows the barrels used to ship fresh oysters and some of the vehicles used to deliver seafood to markets and restaurants around the region.

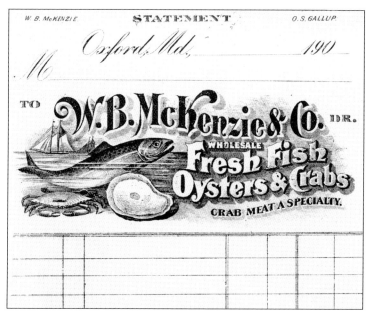

With the numerous packinghouses in Oxford and throughout the region, the competition was fierce. Many of the local operations, including W.B. McKenzie & Co., designed elegant business forms and stationery to help promote their products.

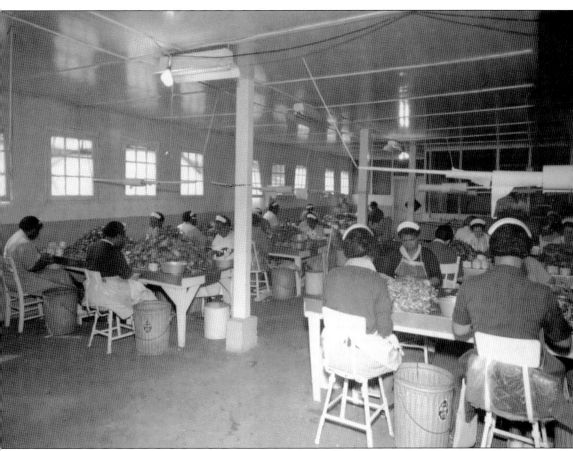

Crab picking was a highly specialized skill. Once the crabs were steamed, teams of women, both Black and White, worked long hours removing every last bit of meat from the shell and sorting it by size and quality. For decades, these workers were paid by the pound, and the best of them could make a fair living. Then the state instituted laws that required payment by the hour, and the incentive was lost.

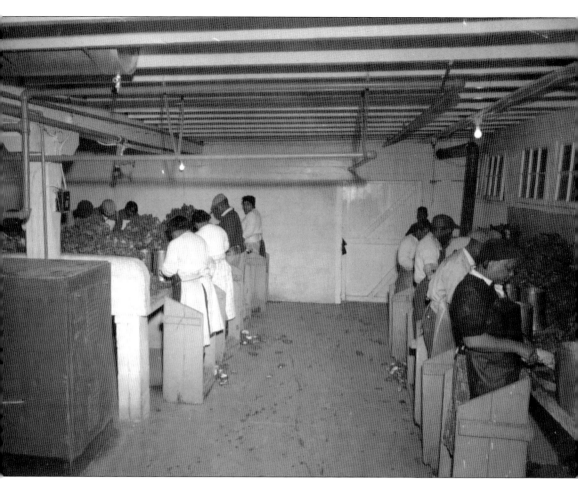

Shucking oysters was grueling, tedious work. Both men and women would stand for hours, thrusting a knife blade between the shells to extract the oyster meat. Skilled shuckers could open an oyster every five seconds, delivering from 15 to 20 gallons of oyster meat per day. At day's end, they were covered with brine, shell, and slime.

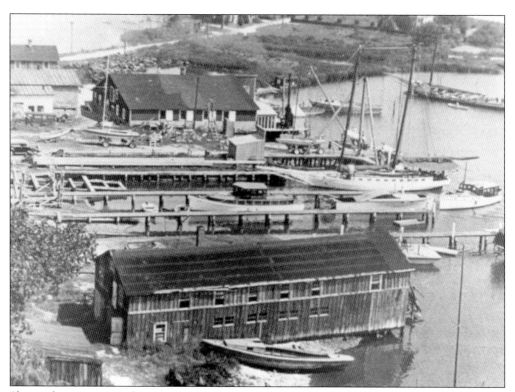

Shipyards were among the very first businesses established in Oxford. They were essential to the young colony's survival during the 17th and 18th centuries, when all trade was carried out on the water. Oxford's watermen also relied on local shipyards to build, maintain, and repair the vessels they needed for their livelihoods. And with the rise of recreational boating in the late 19th century, Oxford's boatyards maintained and built fleets of pleasure craft.

The growing reputation of Oxford's boatyards and the increasing demand for both wartime and peacetime boat building and repair meant that a specialized labor force of shipwrights, mechanics, sail makers, smiths, and riggers made Oxford their home.

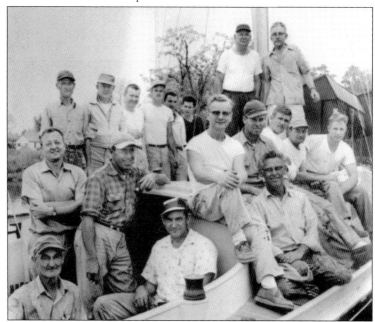

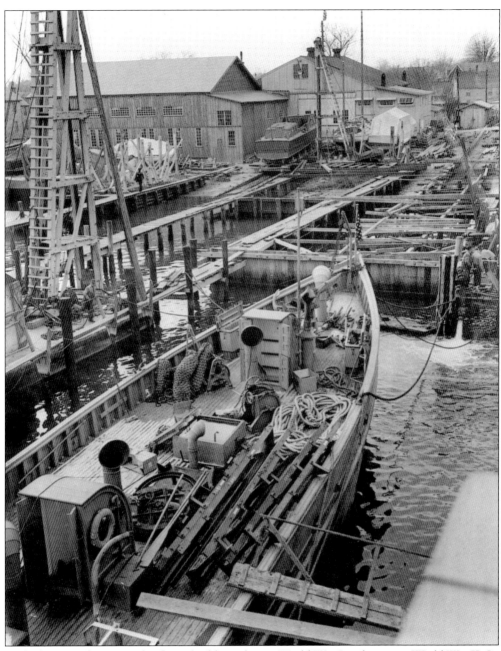

Oxford Boatyard supported military build-ups during World War I and again in World War II. So many coastal patrol boats slid off the ways (or were launched) there in the 1940s that the yard was awarded the Army-Navy "E" Award for "Excellence in Wartime Production."

Large boatyard sheds like this one were essential if production was to continue year-round. The oppressive heat of the summer months and the cold of winter were damaging to both men and materials. (Courtesy of THS.)

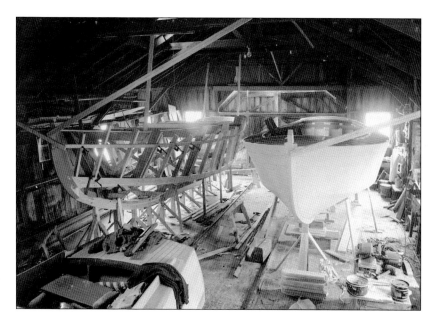

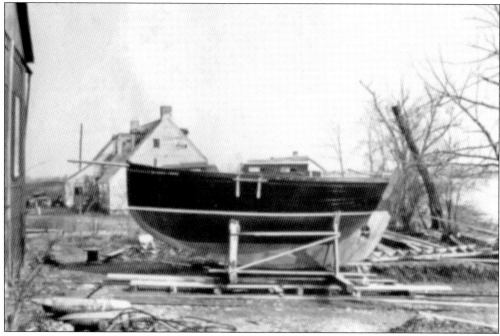

Ralph Wiley came to Oxford in 1928, attracted by the numerous yards building bugeyes, skipjacks, and schooners for the oystering trade. But his dream was to design and build fast, beautiful pleasure boats. He succeeded brilliantly at his little boatyard along Town Creek. Behind one of his new double-ended hulls, is Byberry house. Wiley bought this house, built around 1695, for just $250 and moved it from its original location on Morris Street down to his yard so he could live right on the premises. Note the absence of trees.

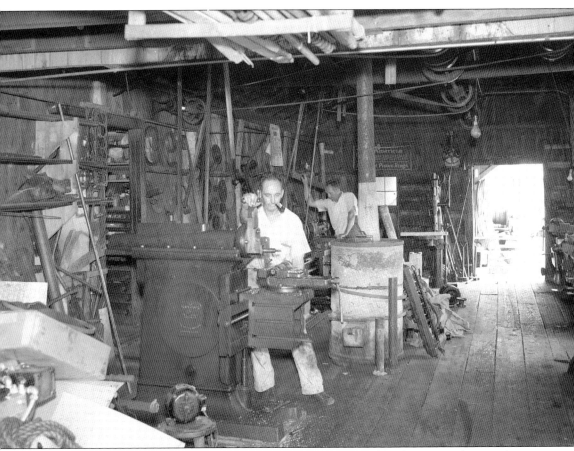

Walter and Arthur Crockett owned a yard on Town Creek, and Walter is seen here working in their machine shop in about 1940. The transition from sail to engine power radically changed the boatbuilding trades. Machines like windlasses that hoisted anchors and hauled in the heavy oyster dredges were the first great improvements, but it was the introduction and gradual adoption of steam, diesel, and gasoline engines that changed maritime work forever. (Courtesy of THS.)

Six

WORKING ON THE LAND

The period from the 1880s to the 1930s was a high-water mark for Oxford's commercial businesses. Fueled largely by the oyster boom, the town's population grew to over 1200, almost evenly divided between White and Black residents, and their demand for goods and services grew steadily.

In addition to a dozen bustling packinghouses, at least 68 businesses were operating in the village: 11 groceries, six clothing stores, four general merchandisers, two shoe and boot shops, two confectioners, two milliners, two livery stables, a barber, a butcher, three carpenters, a blacksmith, two dentists, two doctors, and a bank. Many of these were located along Morris Street, which had become Oxford's central business district, but the Black neighborhoods off Factory, Market, Tilghman, Mill, and Stewart Streets supported their own local shops.

Profiting from these growing businesses, Oxford's families were able to invest in new houses, gardens, schools, churches, and clubs, while the town made improvements in street lighting, water systems, and even brick sidewalks.

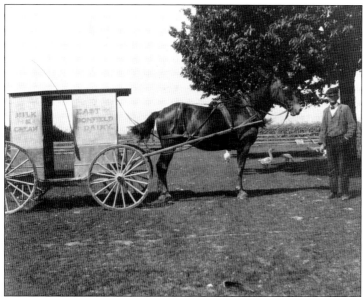

There were numerous dairy farms around Oxford throughout the 1900s. Even before roads were paved and trucks were commonplace, it was the practice to deliver fresh milk and cream daily to the town's stores and residential customers. The East Bonfield Dairy's milkman, with his horse and wagon, stopped on his rounds long enough to be photographed.

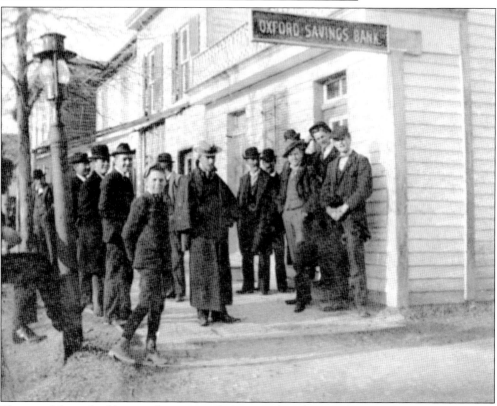

This wood-frame building on the corner of Morris and High Street became the first office of the Oxford Savings Bank in 1890. Around 1910, a new brick bank building opened across the street. In addition to being fireproof, the new bank featured a massive safe. Despite these safeguards, the bank suffered a catastrophic failure in the Depression of 1933. Many of Oxford's businesses and families, probably including some in this photograph, lost all their savings.

William H. Seth was one of Oxford's leading businessmen during the second half of the 19th century. In addition to co-owning two packinghouses, he also operated this general store on Morris Street and had numerous other real estate investments. Members of the Seth family and store workers stand proudly for this c. 1900 portrait.

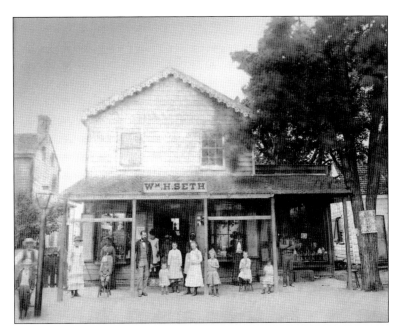

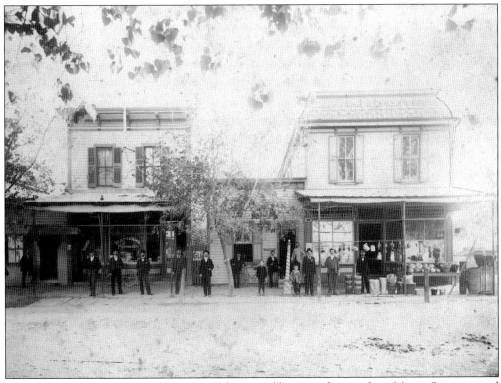

These adjacent storefronts made up part of the central business district along Morris Street around 1900. From left to right are Matthews Pharmacy, Stevens' Barber Shop (with barber pole), and "Uncle Ed" Parsons' General Store. All three buildings were destroyed by fire in 1932 and were ultimately replaced by the new town office building.

71

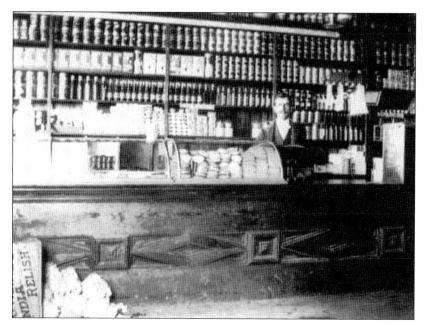

This interior of Parsons' well-stocked store features purveyor Tom Davis at his post behind the counter. Owner Ed Parsons spent most of his time in a shop behind the store carving decoys for clients far and wide. These decoys are highly valued today.

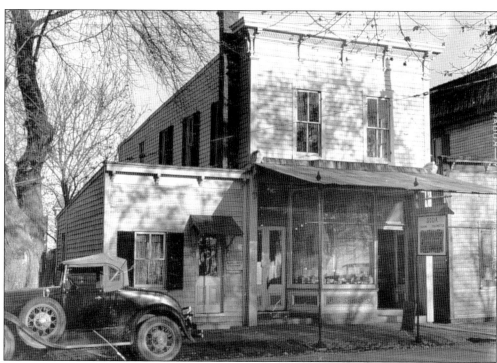

The tiny office of Dr. Joseph A. Ross, the one-story section on the left facing Morris Street, is conveniently located next door to Matthews Pharmacy. The sign on Dr. Ross's office indicates that his office hours are 2:00 to 3:00 p.m. He might spend the rest of the day making house calls in his convertible automobile. This image dates around 1935.

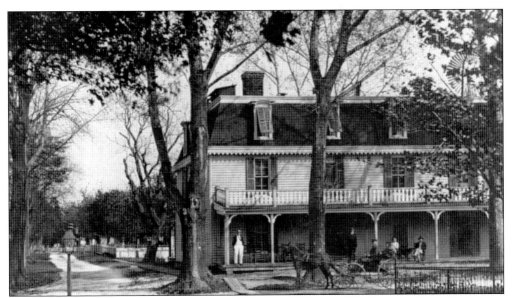

A small dwelling was first built on this site around 1710 and used by Oxford's most successful entrepreneur, Robert Morris Sr. In succeeding decades, the structure expanded into a popular boarding house and even a dispensary for wounded Civil War soldiers. Then, in 1875, it was greatly enlarged and reopened as the River View House. Dilapidated by the 1940s, it was restored, enlarged again, and reopened in 1950 with its current name, the Robert Morris Inn. Notice the windmill behind the hotel, used for pumping water to the guest rooms.

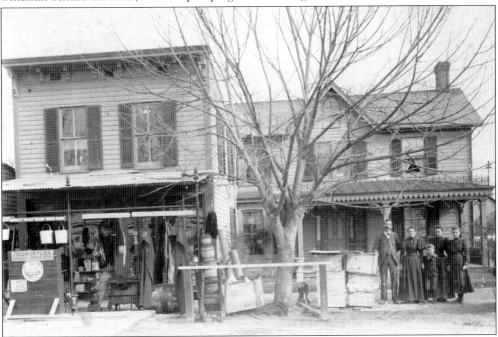

Oxford had a bustling downtown business district at the turn of the 20th century but it always included some residential houses as well. William Bergman's beautiful two-story house on Morris Street was located right behind his storefront. The Bergman family poses outside the store, proud of the merchandise on display along the sidewalk.

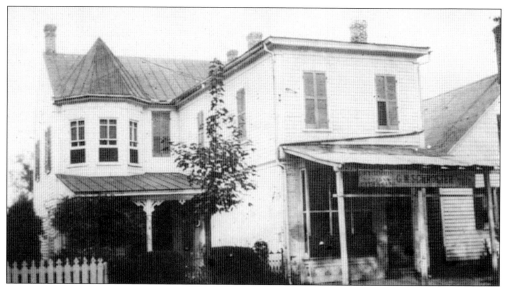

This c. 1910 photograph shows the dry goods store located at 214 N. Morris Street when it belonged to George Schroeder. Years later, this was the location of the furrier shop owned by Thomas Taylor, retired principal of the Oxford high school. With a bounty of local muskrats, a furrier shop could be successful even in a community accustomed to sweltering summer heat.

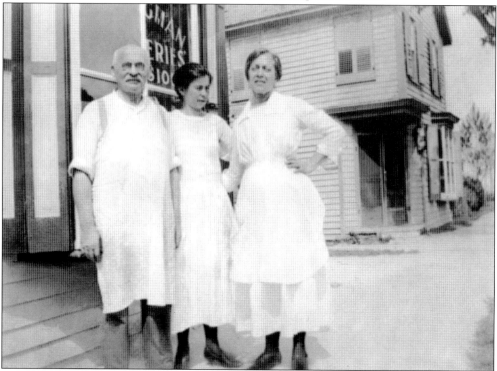

Herman Bringman, his wife, and daughter pose outside of their store on the corner of Tilghman and Norton Streets in the 1940s. Their grocery business was in the center of Oxford's Black neighborhood, rather than on Morris Street with most other merchants. Oxford was a segregated community but enjoyed friendly and profitable race relations.

The population of Oxford in the first half of the 20th century was evenly divided between Black and White families, and the demand for goods and services was growing fast. Emile and Margie Gibson were among the shopkeepers and active community members who opened businesses in the Black neighborhoods on the east side of Morris Street, especially along Tilghman, Stewart, Norton, and Mill Streets.

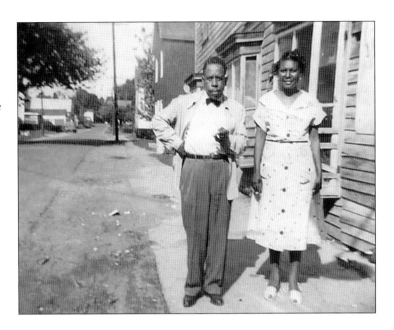

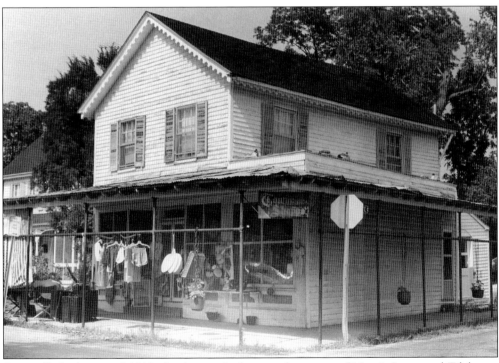

Originally built around 1860, the dry goods shop on the corner of Morris Street and Tilghman Street was purchased by Jeremiah Valliant in 1904. His grocery business passed to his daughter, Miss Louise Valliant Willis, who added merchandise of all kinds. Although she named her store the Towne Shoppe, locals always referred to it as "Miss Louise's." The shop was still in business into the 1990s, but the building deteriorated and was eventually torn down.

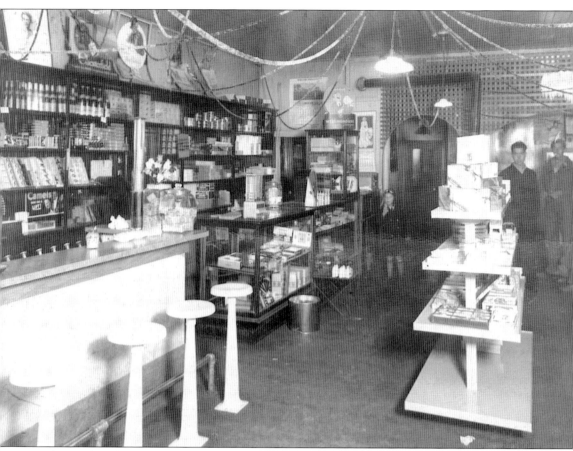

This is what the interior of Thompson's confectionery store and soda fountain on Morris Street looked like around 1940, and then in the early 1950s, Kreeger's was established. Kreeger operated his store and drove a school bus as well. Located at the corner of the town park, this building was all that survived the fire that destroyed the huge Eastford Hall Hotel in 1894. After many other uses over the decades, the building once again holds a business that sells coffee and ice cream. The soda fountain pictured here was preserved by the Oxford Museum and is now back in its original home.

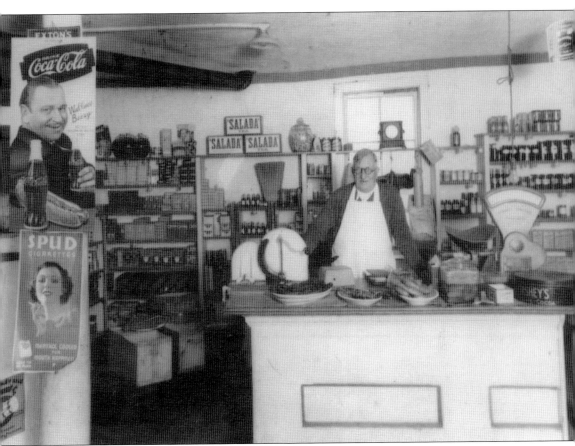

Jim Frey managed yet another of Oxford's grocery stores at the turn of the 20th century. It was located adjacent to the River View House, close to passengers arriving or departing on the steamboats or the Oxford-Bellevue ferry. He also operated a pool hall and a bowling alley there.

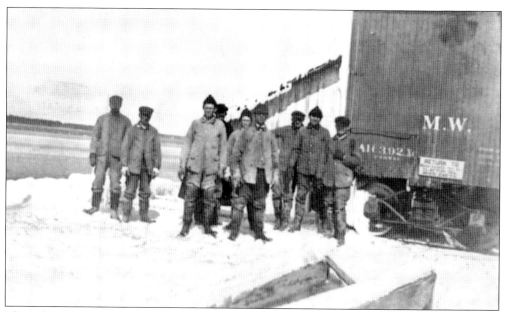

The railroad terminal at Pier Street was a hive of activity year-round. This chilly view of workers during the winter of 1917 offers a glimpse of the labor required to maintain the facilities and keep goods flowing to and from waiting railway cars.

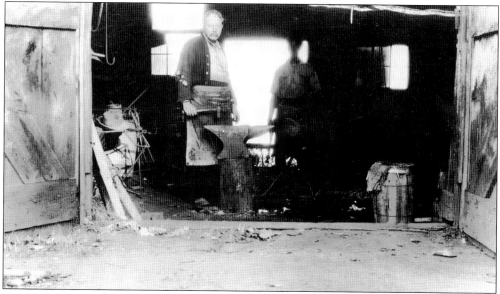

Oliver H. Ridgeway was a blacksmith in Oxford who provided a wide range of services to farmers, boat builders, shopkeepers, and horse owners. His shop was on Tilghman Street, next to Oxford Boatyard and just behind Prichard's sail loft.

Oliver H. Ridgeway did not work at the forge every day. Here, he is posing in his Sunday best.

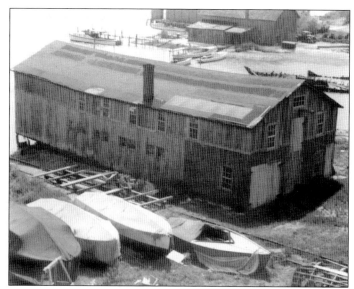

As a center for commercial and recreational sailing vessels, Oxford required the skills of a sailmaker. Capt. Dave Pritchard's sail loft on the grounds of the Oxford Boatyard was a two-story structure with storage room for new canvas and completed sails on the ground floor. Above was an open loft for laying out, cutting, and sewing sails.

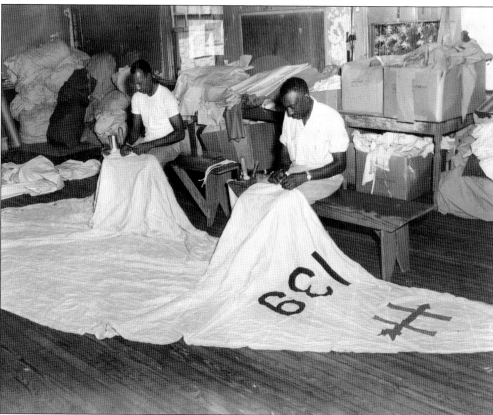

In 1928, the young Downes Curtis joined David Pritchett, an Englishman who had a sail loft near the Oxford Boatyard, as his apprentice. When Pritchett died in 1936, Downes took over the business, with his brother Albert assisting. The Curtis brothers moved their workplace into the old Black schoolhouse on Tilghman Street where they had both been students. Downes became famous in the area for making sails for log canoes as well as for elegant yachts. (Courtesy of THS.)

British plantations were established in Oxford in the late 17th century, growing tobacco for export to Europe. For a few decades, tobacco was even the legal tender used in business transactions. But after America won its independence from Britain, and as the soil became depleted of the nutrients needed for quality tobacco, wheat took over as a major commodity on the Eastern Shore. Some wheat is still grown and harvested today on local farms.

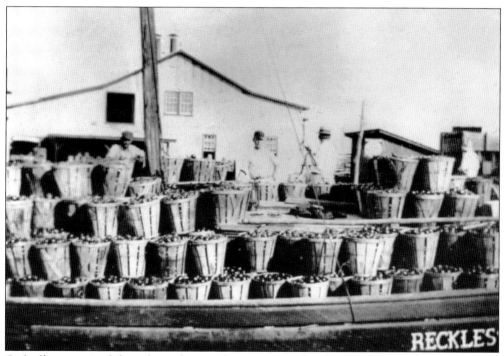

Oxford's canneries did not limit their work to oysters and crabmeat. Fruits and vegetables were becoming a huge part of the region's agriculture, especially after the decline of shellfish by the mid-20th century. Tomatoes in particular were well-suited to the canning process and in high demand by both military and civilian suppliers until California's Central Valley gained market dominance. (Courtesy of THS.)

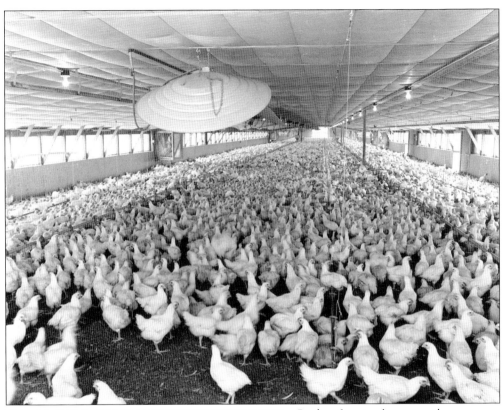

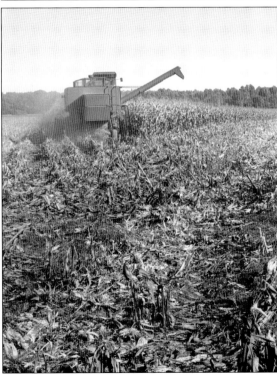

Poultry farming began on the Delmarva peninsula in the 1920s, when chicken was still a luxury food. Today, the poultry business dominates the agriculture of the Eastern Shore. There are 2,600 chicken farms on Delmarva, producing about 570 million chickens annually. Most of the region's cropland, including the farms that surround Oxford, is now dedicated to cultivating corn and soybeans to feed some of those chickens.

Seven

COMMUNITY SERVICES

Located 10 miles from Easton, its closest neighbor, Oxford residents needed to establish their own community services. The first colonial mail service arrived in May 1695 as part of a free system that made eight deliveries a year from Virginia to Philadelphia. It was not until 1775 that Postmaster General Benjamin Franklin organized a national postal network that regularly served the Eastern Shore, and in 1849 Oxford opened its first permanent post office.

This was well before the first volunteer fire department was finally organized in 1927. Before then, Oxford relied on a bucket brigade. Manpower was summoned to the all-too-frequent fires by ringing a bell at the center of town or blowing a whistle at the railway yard on Pier Street.

Oxford's British settlers brought their Christian faith with them, but until the 1850s, there were so few parishioners that the village did not need its own churches. A walk or ride to the John Wesley Chapel on Oxford Neck or St. Peter's church in White Marsh was required and became an all-day event. As Oxford's population grew dramatically at the end of the 19th century, Holy Trinity Episcopal, St. Paul's Methodist, Waters Methodist Episcopal, and United Methodist churches opened their doors.

This was also the era of fraternal organizations, including the Freemasons, the Order of Odd Fellows, and the Improved Order of Red Men. Even in small towns like Oxford, chapters were formed to provide bonds of fellowship to both Black and White residents.

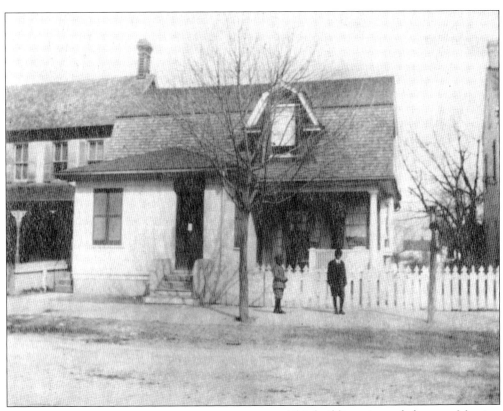

This building pictured above on Morris Street served for decades as the town post office. The original office was just the small building on the left, but it was enlarged to provide living quarters for postmistress Mary W. "Molly" Stewart. When Stewart inherited the position from her father in 1877, she was just 18 years old and one of the first female postmasters in the United States. The position was a political appointment, which Molly had to defend from male challengers over the years by outscoring them on civil service exams.

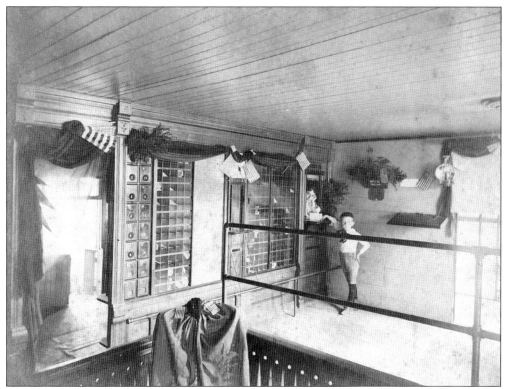

This photograph shows the inside of the post office and Molly Stewart chatting with a young customer. Mail was delivered twice daily by train, and people came there twice a day to collect it and share the local gossip, making the post office a hub of social interaction in Oxford. In October 1939, Stewart went to Washington to attend the National Association of Postmasters' Convention as the guest of honor. She also had tea at the White House with First Lady Eleanor Roosevelt. Stewart served for 63 years, longer than any other postmaster in the United States.

For over a century, residents living in the village of Oxford have been required to pick up their mail at the post office. For those living on the outskirts of Oxford and out of town, mail was delivered twice daily by Howard Leonard, who drove a one-horse Dayton wagon with a box-like structure in the middle. One pundit commented that it looked like "a one-hole privy suspended between the front and back wheels."

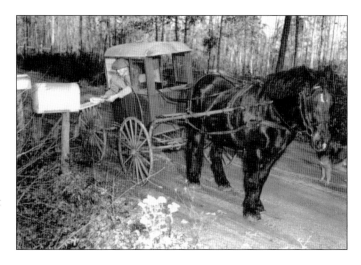

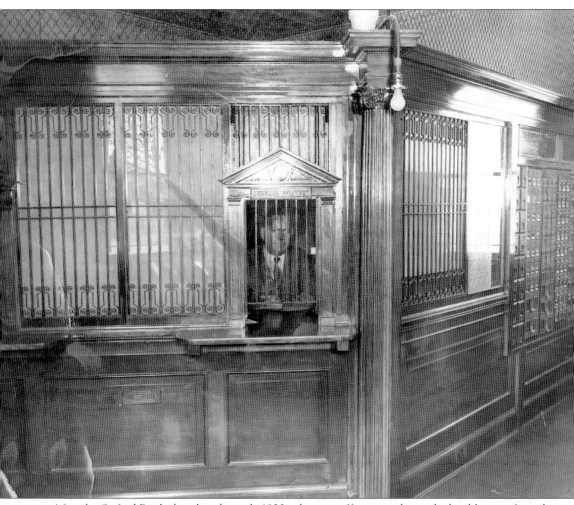

After the Oxford Bank closed in the early 1930s, the post office moved into the bank's more formal and secure building just up Morris Street. Pictured here is postmaster John L. Thompson, who took over upon the retirement of Molly Stewart.

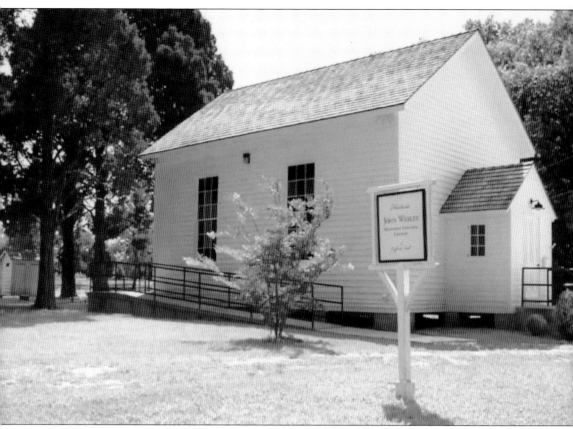

The John Wesley Methodist Episcopal Church is an enduring landmark of community, faith, and perseverance and has played a significant role in the lives of the region's African Americans. The original church was organized in 1838 on a tiny eighth-of-an-acre parcel to serve an area then known as Oxford Neck. Records from 1851 show that 31 White and 26 Black congregants worshipped together here. In 1875, a new single-story frame structure, pictured here, replaced the original small chapel. For the next decade, the John Wesley Methodist Episcopal Church remained the only place of worship available to the region's African Americans. When the church closed its doors for services in 1978, descendants of the church members organized a movement to preserve the property.

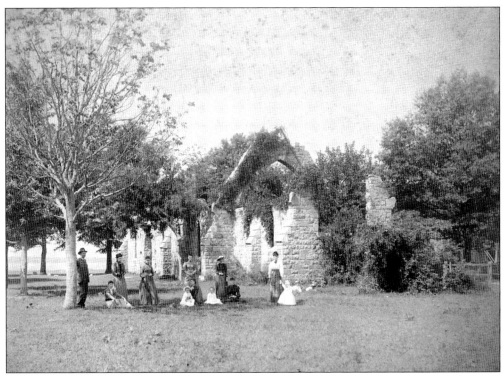

Since the mid-19th century, Oxford has supported four churches: Holy Trinity Episcopal, St. Paul's Methodist Episcopal, the Oxford United Methodist, and Waters United Methodist Churches. Construction of the stone Holy Trinity Episcopal Church building was started in 1853 by Gen. Tench Tilghman; however, due to financial problems and the outbreak of the Civil War, it was never finished. For 40 years the structure remained a picturesque, roofless shell, locally dubbed "the ruins." The church was finally completed in 1903.

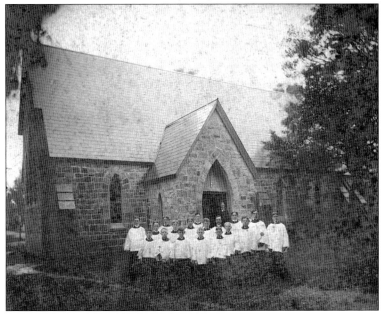

Members of the men's and boys' choirs stand outside the completed Holy Trinity Episcopal Church in the early 1900s. The roof was slate, and the walls were built of granite quarried at Port Deposit, Maryland, on the Susquehanna River and transported 70 miles to Oxford by boat.

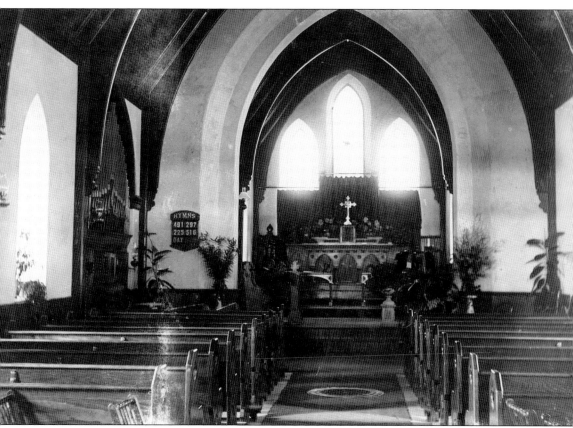

Holy Trinity's original oak altar was a gift from Oswald Tilghman Jr., a grandson of founder Gen. Tench Tilghman and Ella S. Tilghman, Tench's daughter, who personally executed its intricate carvings. When a fire gutted the church in 1945, the stone walls survived, but all the elaborate wooden trim and furniture were destroyed. The church was soon rebuilt according to 19th-century architectural specifications. Ella and her sister Maria are buried in front of the church, their grave marked by a low boxwood hedge.

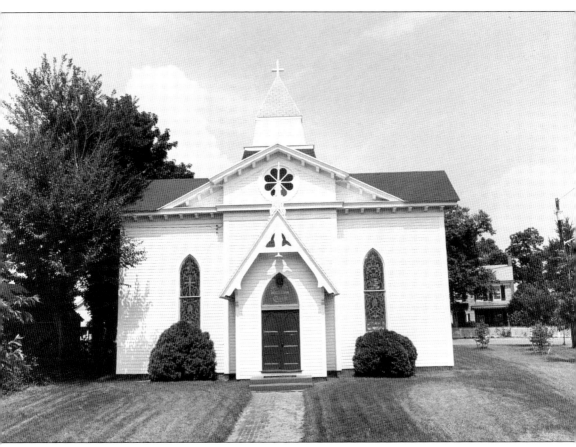

Built in 1856, St. Paul's was consecrated as a Methodist Episcopal Church. Its congregants were bitterly divided during the Civil War, and it is believed that when news of Gen. Lee's surrender was announced from the pulpit on Sunday, April 9, 1865, supporters of the Confederacy left by the windows to avoid walking under the American flag that hung over the entry door. St. Paul's later served as the home of the Pilgrim Holiness Church. This building is now privately owned, beautifully restored, and made available for community events.

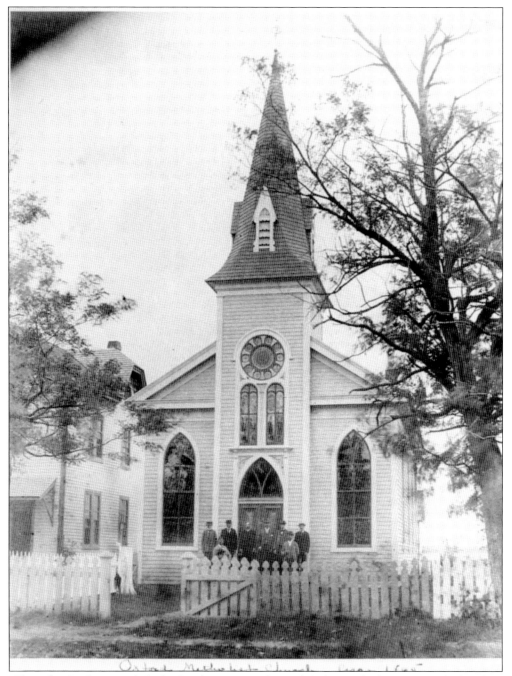

When the Civil War ended, the Southern sympathizers left the Methodist Episcopal Church of Oxford and started the Oxford Methodist Protestant Church, which stood approximately where the present-day Oxford United Methodist Church stands. Note the old school buildings to the left that were in the park. By 1941, their differences long forgotten, the two churches merged to become the Methodist Church of Oxford.

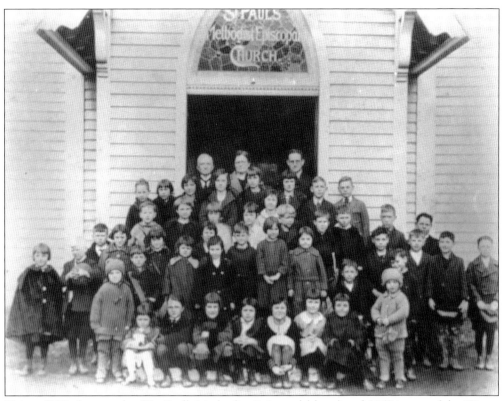

This c. 1930 photograph of St. Paul's Methodist Episcopal (above) and 1957 image of the Waters Methodist Church congregation (below) both feature a large number of children. Today, one would not find as many children attending services, as the town is populated primarily by retirees and second-home owners. The Waters Methodist Church remains the Oxford home of the African American Methodists and is named for its first pastor, Rev. D.G. Waters. Before it was built in 1883, African Americans living in Oxford attended services at the integrated John Wesley Methodist Episcopal Church (preserved today as a historic site) just outside of town on the Oxford Road.

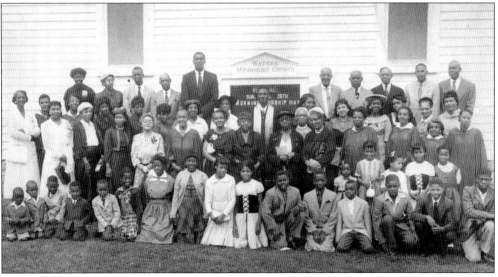

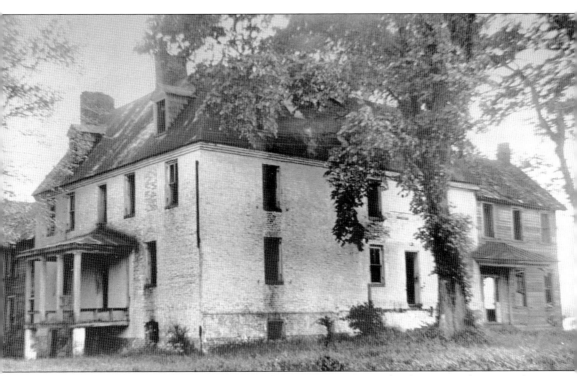

Pictured here is Bacon's Charity Working School, built in 1750 to provide education and vocational training for both poor White and Black children. Rev. Thomas Bacon (1711–1768) was an Episcopal priest, musician, poet, publisher, and author. Considered the most learned man of his day in Maryland, he was the first compiler of Maryland statutes. He lived in Oxford for a time and was the first curate of St. Peter's parish at Whitemarsh. He was dedicated to the education of children and the religious education of the area's African Americans. In 1750, he began soliciting subscribers from other colonies for funds to provide free manual training without regard to race, sex, or economic status. The building later served as the Talbot County Almshouse.

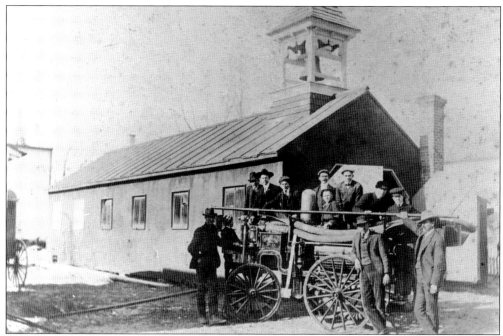

In the 1880s, the Oxford fire company consisted of an antiquated hand pumper using water from the river, a hose reel, and 800 feet of hose, all housed in a wooden building on Factory Street. The equipment was not sufficient to stop a major fire, like the one that gutted the Eastford Hall Hotel in 1894 or the 1904 blaze that destroyed the icehouse. At best, the pumper and its crew could prevent fire from spreading to surrounding structures.

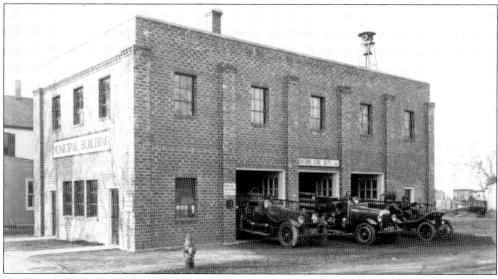

The year 1932 was an especially destructive one for Oxford. A large fire on Morris and Market Streets destroyed seven buildings, including Parsons' store, Barnetts' Drug Store, and Stevens' Barber Shop. Another fire destroyed the Oxford Fire Company's building. The company soon relocated to the town office building where the current Oxford Town Hall now stands. When the new firehouse was built on the edge of town in 1963, the vacated town space provided a home for the newly formed Oxford Museum.

In 1926, the town purchased a used 1916 Model T Ford fire truck to replace the hand pumper. The truck was turned over to the Oxford Volunteer Fire Company when it was formally organized a year later. The town installed a new water system in 1927, with a 100,000-gallon water tank and fire hydrants. In this photograph, Officers William Colburn (left) and Victor Cox, volunteer firemen, are wearing the company's first uniform. Manpower was summoned by ringing a bell in the center of town on top of the town hall and at the railroad depot on Pier Street.

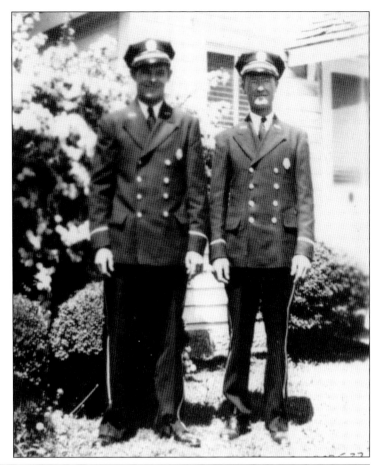

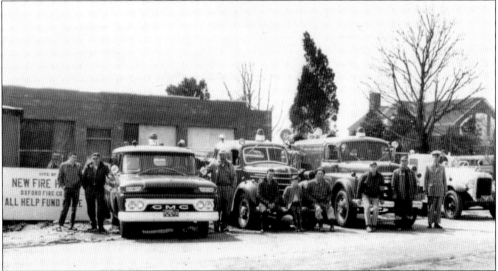

The new Oxford Fire Station 10, dedicated in 1963, was constructed on the Oxford Road adjacent to the elementary school. It continues to serve the community today but has undergone a major expansion to accommodate the latest and largest new ladder and pumper trucks.

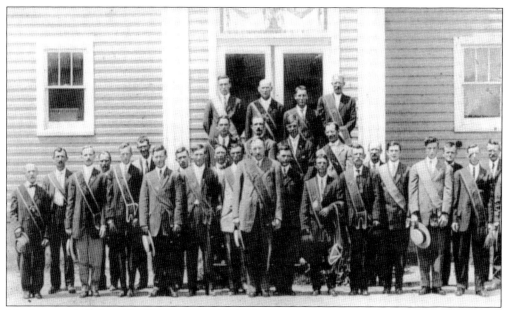

The Improved Order of Red Men was established in 1834 to encourage a love of the United States and to promote the "principles of liberty." Its rituals and regalia are modeled on what White men assumed that Native Americans used. This photograph shows an Oxford lodge members' convention in 1910 (above) and then in costume as the Washatella Tribe (below) posing in front of the Oxford High School in the town park. In its day, the Red Men's Lodge on Morris Street was an entertainment and social center for the town, with an auditorium that could seat 200 people for silent movies and a dressing room in the basement to accommodate theater productions.

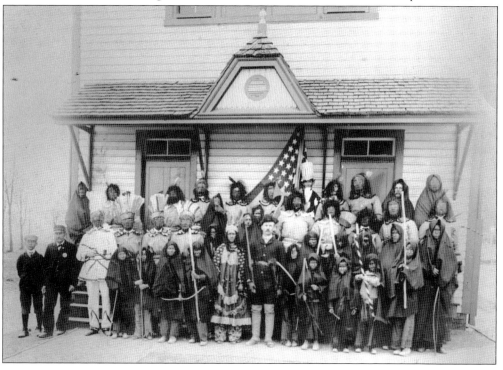

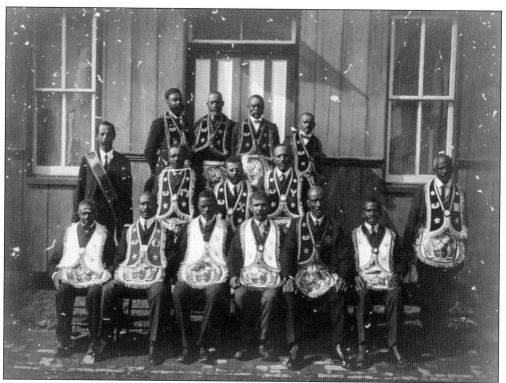

The Odd Fellows are one of the earliest and oldest fraternal societies, dating back to 1730 in England. The first Maryland order was formed in Baltimore in 1819. The society provided for the social welfare of Oxford's African American residents and was a center for the Black community's social events. Oxford's Odd Fellows' lodge was housed in this two-story tin-clad building, built on Tilghman Street in the 1890s.

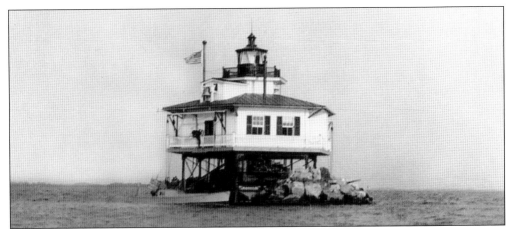

Located two miles south-southwest of Town Point, this lighthouse guarded the entrance to the Tred Avon River. Capt. John E. Faulkner was the lighthouse keeper until his death in 1929 at age 72. In the bitter winter of 1918, a huge ice jam knocked the lighthouse from its foundation and, on orders from Washington, Faulkner abandoned it. It was replaced by a new manned lighthouse, which was dismantled by the Coast Guard in 1964 and replaced with an unmanned automatic bell buoy and flasher.

Oxford has had its own public library since at least 1929. Originally located in a private home, it moved briefly to the old bank building, then to an aircraft spotting shed, then to the municipal building before finally having a home of its own. After a long fundraising campaign that included selling cinder blocks to local schoolchildren for 25¢ each, the library opened its new doors in October 1950.

Eight

OXFORD AT PLAY

Oxford's history is not only a story of business and enterprise. Just as water was central to work for many residents over the centuries, it was also the basis for many of its pastimes. Both residents and visitors took regular advantage of the town's waterfront, finding time for fishing, crabbing, waterfowl hunting, swimming, and boating.

Casual boat races were common, but as they increased in both number and intensity, clubs were established to organize regattas and competition among the sailing boats unique to the Chesapeake Bay: skipjacks and log canoes. In the winter, when the rivers froze over (which happened more frequently in the past), ice skating and iceboat racing were common. Even live theater came to Oxford by water. The Adams Floating Theatre company regularly brought actors, a stage, and sets up the Tred Avon River on its barge.

On land, organized sports, especially baseball, were growing in popularity across America, and Oxford joined the movement. Both within and outside the local schools, Oxford supported all manner of sports teams.

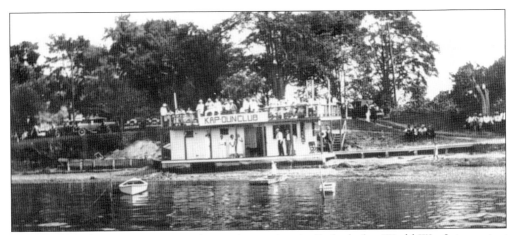

As boat racing became an increasingly popular pastime in Oxford after World War I, it was just a matter of time before a yacht club was organized. The Kap Dun (a play on the word "captain") Club was inaugurated in 1932 by a few local sailors, with Jeremiah Valliant Jr. as its first president. In 1937, it changed its name to the Tred Avon Yacht Club and located its new clubhouse on land owned by the town on Oxford Point.

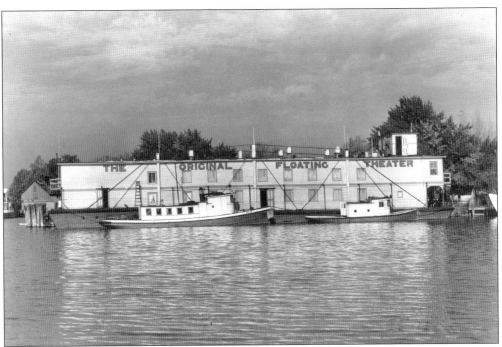

The Adams Floating Theatre was the original "showboat" on which Edna Ferber based the famous novel that became a hit Broadway musical. Touring around the Chesapeake Bay, their stage productions included comic sketches and concerts as well as plays like *The Girl of the Golden West* and *Ten Nights in a Barroom*. Once the vessel was tied up at Oxford's steamboat wharf, the cast and crew would march up Morris Street and through town to drum up interest in their latest show.

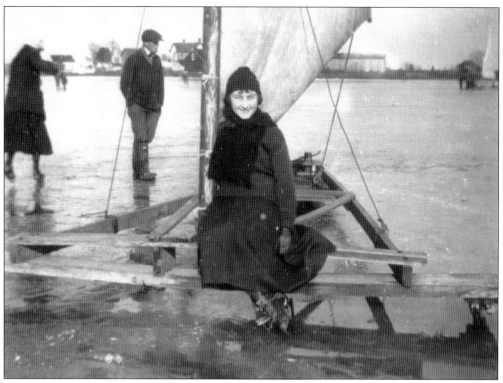

Winter is short in Oxford, but area residents still find time to enjoy it. Above, a young lady, bundled up for the cold temperatures, rests on a small iceboat while skaters glide by on Town Creek around 1910. Below, an 1890s photograph shows two iceboats racing on the Tred Avon. The sport developed in northern Europe as early as the 17th century and was adopted on New York's Hudson River in the 1790s. As racing spread anywhere there was reliable ice, it became popular on the bay. In the 1900s, local sailors adapted existing summer watercraft or built their own iceboats. In 1977, sailors from around the world gathered in Talbot County for the North American championships. (Above, courtesy of Oxford Museum, below, courtesy of THS.)

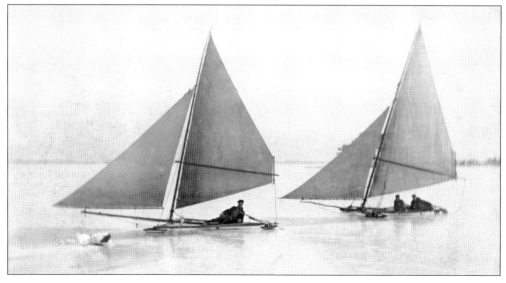

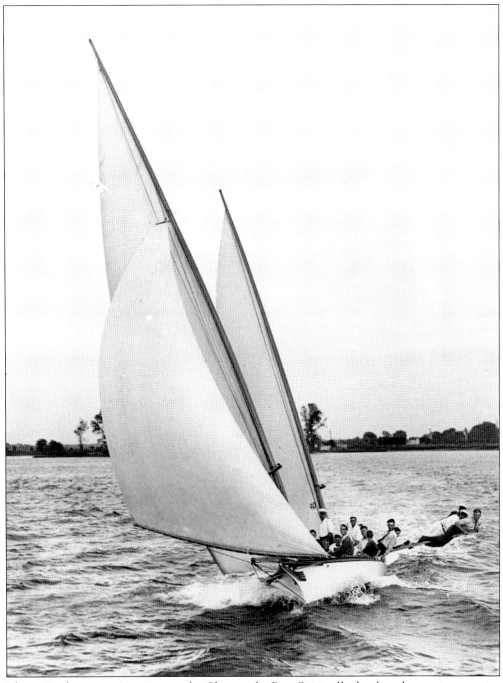

The racing log canoe is unique to the Chesapeake Bay. Originally developed as an inexpensive platform for oyster tonging, the canoes were replaced by larger sailing dredge boats by the end of the 19th century. By 1885, some of the old canoes were converted into spectacular racing machines, and new ones were built for competition.

Today, 18 log canoes are listed in the National Registry of Historic Places, including the two in this image: *Flying Cloud* and *Jay Dee*. Races are still held each summer in Oxford and surrounding areas.

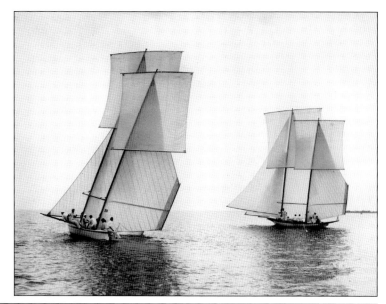

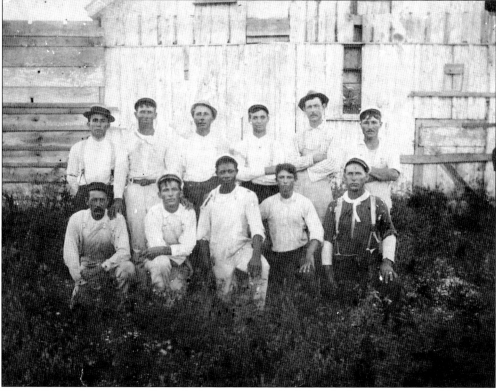

The addition of enormous sails to the log canoes required that the boats carry moveable human ballast to keep from capsizing. A typical log canoe crew would include up to a dozen members. In the early 20th century, most crews were working watermen. Kneeling here from left to right are John Hill, Clarence Dobson, Bill Green, Moe White, and Will Dobson. Standing are Morris Benson, Darius Webster, John Gibson, Buck Richardson, Bob Pyne, and Corlie Hubbard. Buck Richardson, who retired at age 85, was the most celebrated champion.

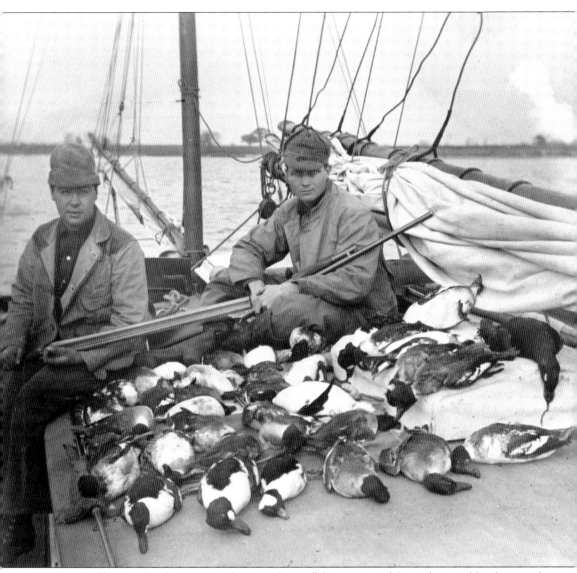

Waterfowl hunting has long attracted visiting "sports" from near and far to the marshlands around Oxford, where they would engage local guides and their dogs to hunt various breeds of ducks and geese. The activity was typically done from camouflaged boats or stationary blinds in the local marshes and involved setting out flocks of carved decoys to lure the birds into range. Once unregulated, the activity resulted in the wholesale slaughter of hundreds of thousands of birds. Today, strict limits apply.

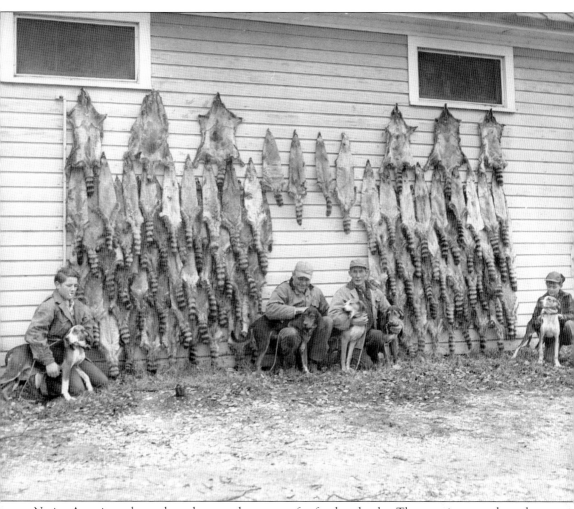

Native Americans hunted muskrats and raccoons for food and pelts. The practice was adopted by European settlers, who introduced coon hunting dogs. Pictured from left to right are hunters Harold Simmons, Bill Wrightson, and J. Melvin Johnson in Royal Oak, just across the river from Oxford. In the early 1990s, protests by animal rights groups resulted in a crash in the fur-bearing market. Since then, coon hunting has lost popularity.

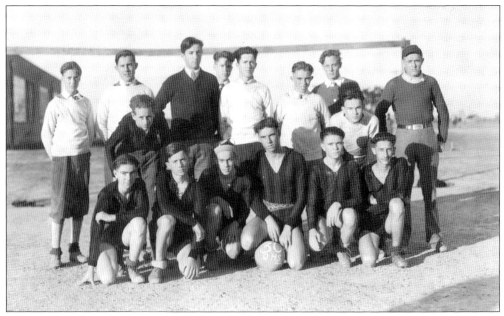

By the 1920s, organized sports were considered an important part of every child's education. Oxford High School's population had grown large enough by then that it could field several girls' and boys' sports teams. Here, the 1931 boys' soccer team poses for a photograph in front of the goal positioned right next to the new school building.

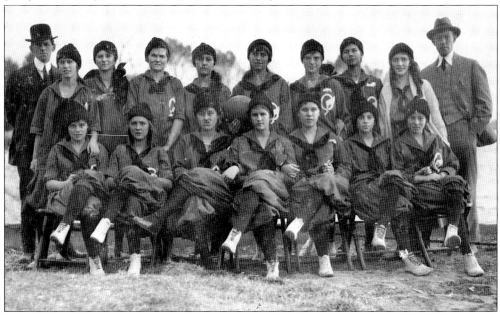

The Oxford High School girls' goal ball team was Talbot County champion in 1915 and 1916. In goal ball, two teams of three players each face each other, blindfolded, and attempt to roll a ball containing bells inside over the opponent's goal line. From left to right are (first row) Louisa Valliant, Eleanor Donohoe, Evelyn Smith, Irma Hoyt, Helen Crockett, Fannie Hoyt, and Carrie Moore; (second row) coach R.L. Hoyt, Doyle Dawson, Grace P., Margaret Stewart, Mable ?, Chris Matthews, Dorothy ?, Virginia Gallup, and coach F. Hanks.

Nine

OXFORD FROM THE AIR

The geography of the Eastern Shore has always been difficult to map or envision because of its intricate pattern of land and water. Lithographic prints featuring artistic bird's-eye views of American cities became popular before the Civil War, while map makers did their best to represent smaller cities and towns. But once airplane flights became more commonplace and airports more convenient, aerial photography quickly proved its value.

The new practice was adopted locally with enthusiasm, thanks to two intrepid practitioners, H. Robins Hollyday of Easton and Norman Harrington of Oxford. They photographed the area for commercial and private customers through much of the 20th century. The images they captured while hanging out of a small plane's cockpit with a large, heavy camera provide a stunning survey of Oxford's landmarks and trace the area's growth and change. Their views reveal not just prominent natural and man-made features but small details of life along Oxford's streets.

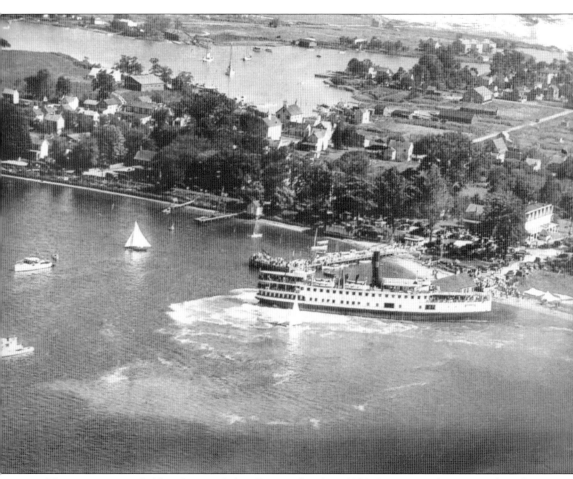

This view was probably taken on Labor Day weekend in 1930. It appears that a steamboat has just arrived with a full complement of passengers. Just beyond the wharf and along the Strand, waiting crowds of pedestrians and automobiles have gathered, and beyond them are prominent Oxford landmarks—the Odd Fellows Hall, the Black schoolhouse, and the boatyards along Town Creek—can be clearly seen.

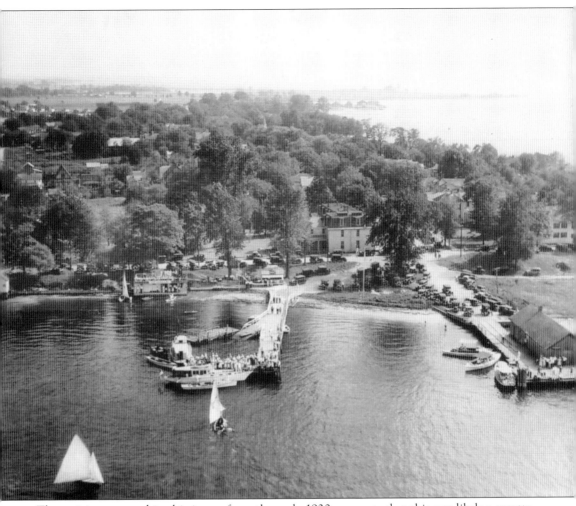

The activity captured in this image from the early 1930s suggests that this was likely a regatta weekend in Oxford. Scores of automobiles are parked along the street by the River View Hotel, numerous small boats and the Oxford-Bellevue ferry are clustered at the docks, and to the left of center, a large crowd of spectators watches from the Kap Dun Yacht Club.

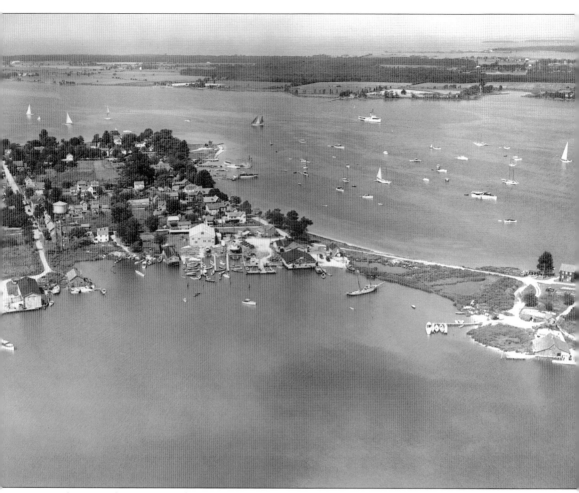

Looking southwest across the Tred Avon River to Bellevue, this view shows the entire length of the Strand, from the steamboat wharf on the left down to Kerr's Island on the right. Until 1882, Kerr's really was an island, requiring the businesses located there to maintain boat service back and forth to the "mainland."

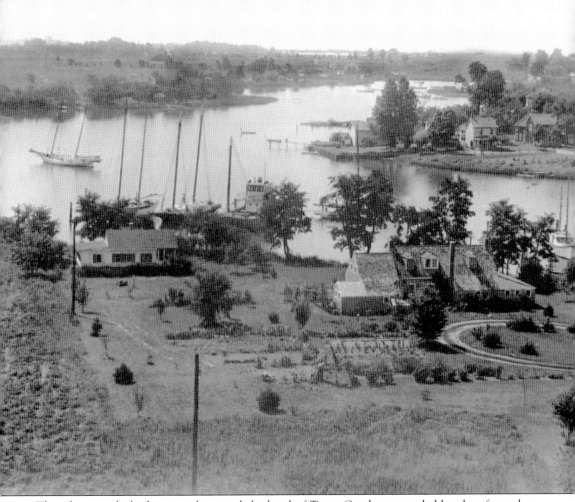

This photograph, looking south toward the head of Town Creek, was probably taken from the top of the Oxford water tower. The building in the right foreground is Byberry, one of Oxford's oldest houses. It was moved to this location by boatbuilder Ralph Wiley. The boats visible in the protected waters of the creek are likely customers of Wiley's Boatyard. Today, this is the site of Cutts & Case Shipyard.

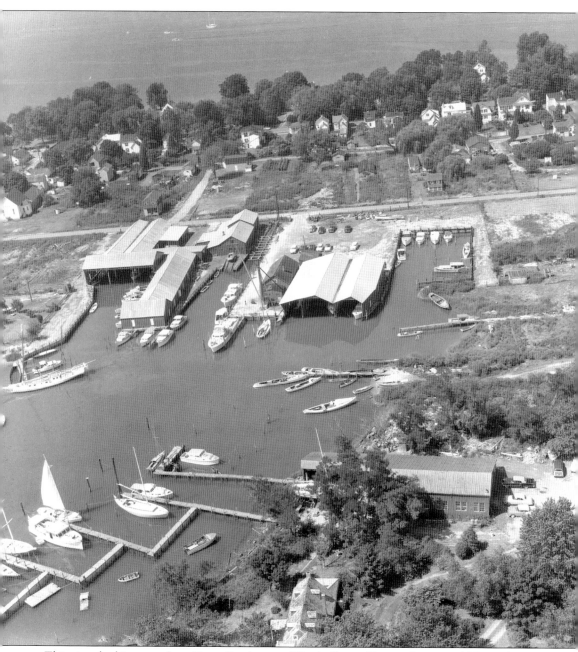

This view, looking west from Town Creek toward Banks Street, Factory Street, and Morris Street, clearly shows the extent of Oxford's marinas and boatbuilding shops. Crockett Brothers' Boatyard was established in 1919 to meet the needs of commercial fishing industries, but by the 1950s, operations had transitioned to serving the growing number of recreational sailors. Wylie's Boatyard and Byberry house are visible in the lower portion of this photograph. (Courtesy of THS.)

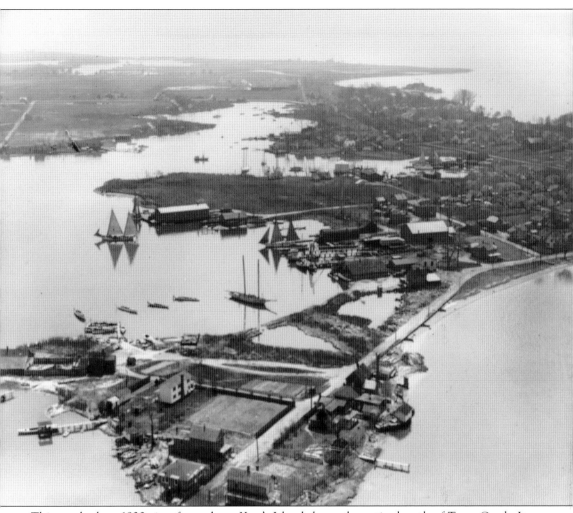

This southerly c. 1930 view from above Kerr's Island shows the entire length of Town Creek. It clearly captures the prominence of maritime activity along the creek and the amount of Oxford's waterfront that was committed to boatyards and seafood packing operations. The residential neighborhoods are barely visible off to the right of the scene.

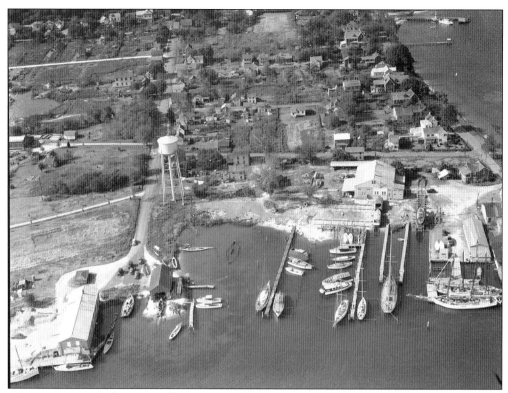

These two views looking west above Town Creek all center on activities along the docks of the Oxford Boatyard. Together, they show not only the evolution of Oxford's waterfront industries but also the growth of the surrounding neighborhoods. Shipbuilding and vessel repair work has taken place here since at least 1866. Dating from the 1930s and 1940s, these both show the expansion of maritime facilities at this location. But they also provide the best look at what was then the heart of Oxford's African American neighborhood. From Tilghman Street on the left toward the Strand on the right, Black-owned homes and businesses dominated the landscape. Just to the left above the top of the water tower is the Black schoolhouse that became Downes Curtis's sail loft, and across the street to the right is the Odd Fellows Hall. (Both, courtesy of THS.)

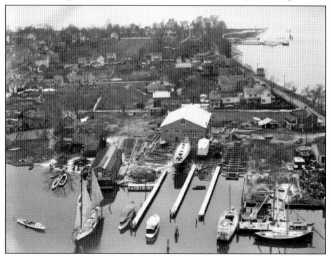

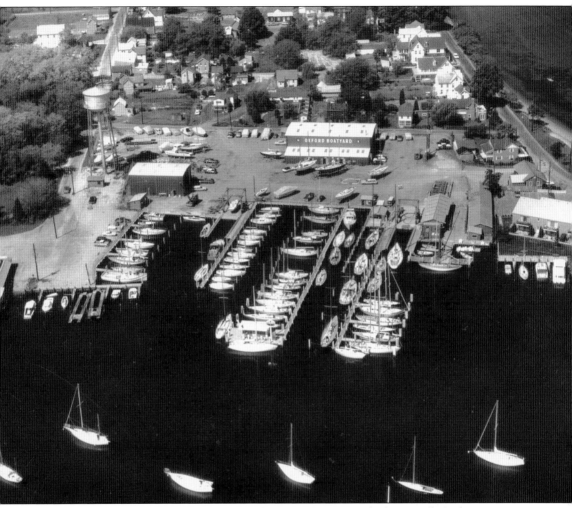

This photograph from the 1960s shows the dramatic changes to the boatyard's facilities to meet the growing needs of recreational boaters. The working schooners, bugeyes, and skipjacks of an earlier era have been replaced by sloops and schooner yachts built for pleasure sailing. Notice how the open land along the waterfront has gone from scrub and dirt to paved parking and boat storage areas. (Courtesy of THS.)

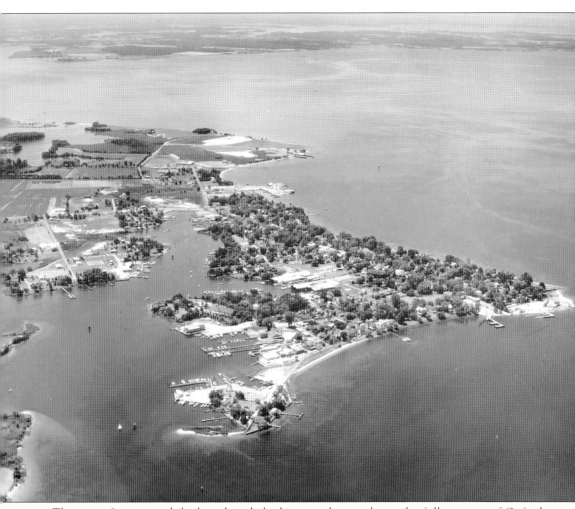

This view, from a much higher altitude looking southwest, shows the full expanse of Oxford, from the boatyards at the entrance to Town Creek, around the Strand to the right, past the ferry dock and yacht club, and then out the mouth of the Tred Avon River. At this time in the 1970s, Bachelors Point at the top left of this view was still largely farmland but would not remain so for much longer. (Courtesy of THS.)

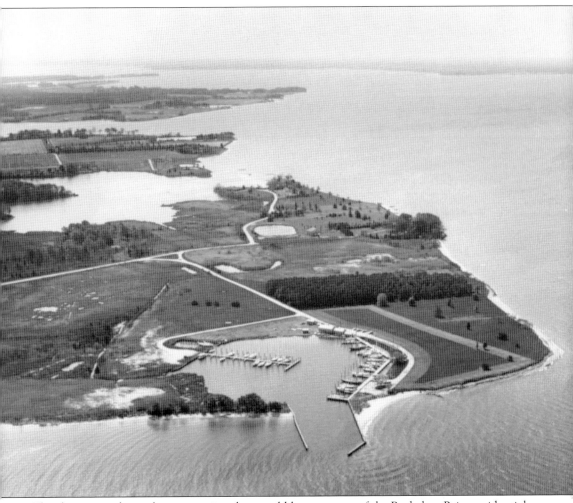

The closer view shows the new marina that would become part of the Bachelors Point residential development in the 1990s. In the distance, across the Choptank River, is Dorchester County and the city of Cambridge.

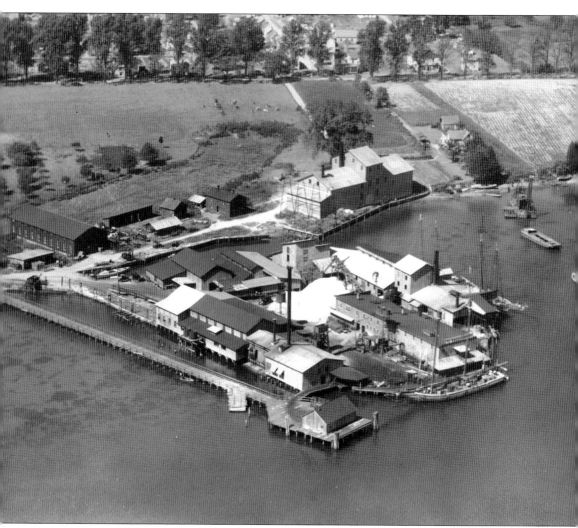

Bellevue was directly across the Tred Avon River from Oxford. Beginning in the decades of the oyster boom, a large complex of packinghouses was built in the predominantly African American village. Operations there were linked to Oxford by family connections and by the laborers who commuted daily from one side to the other by ferry. The ferry's docking slip is visible at the bottom of this image, dwarfed by the size of the industrial buildings. (Courtesy of THS.)

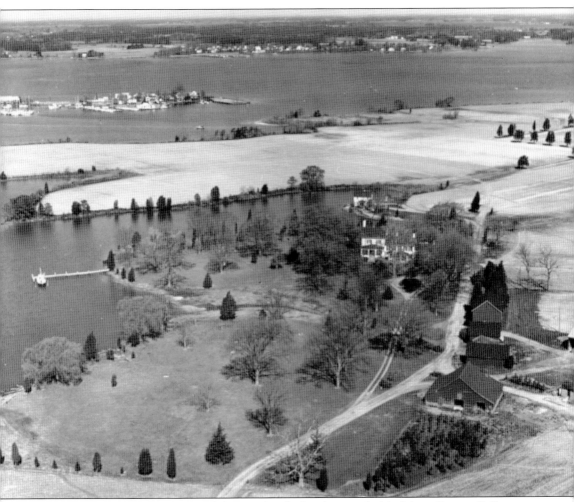

This scene, looking northwest toward the tip of Oxford and across the Tred Avon River to Bellevue, centers on the property known as Plimhimmon, one of Oxford's original 17th-century plantations and home of the illustrious Tilghman family. The extensive farmland was still largely intact in this c. 1950 view. Before the end of the century, however, most of the surrounding acreage would be parceled out as a new residential development called Morgan's Point. (Courtesy of THS.)

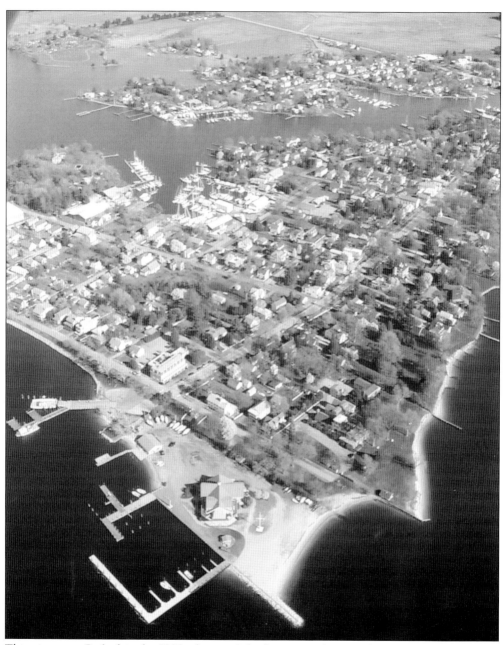

This view over Oxford in the 1990s shows subtle changes to the waterfront. The ferry dock and the Robert Morris Inn still occupy the center of the waterfront. The Tred Avon Yacht Club has replaced the steamboat wharf and icehouse on Town Point. Yet the residences lining the Strand and Morris Street remain, and overall, Oxford's essential character has survived intact.

Ten

WISH YOU WERE HERE

By the 1880s, improving connections via rail or steamboat made Oxford easy to reach for city dwellers from Baltimore, Wilmington, or Philadelphia. Recognizing this opportunity, the town's business leaders encouraged the promotion of Oxford as a pleasant, quiet, and healthy place to visit. Praised by the Baltimore press as the "Cape May of Maryland" and "a far more preferable place than many fashionable watering-places," Oxford grew into a significant tourist destination where an increasing number of hotels, inns, and guest houses offered riverfront bathing, water sports, tree-lined streets, and parks made for strolling.

The village's picturesque charm lent itself to photographic mementos. To help visitors who did not yet have their own cameras to share their experience with friends and family back home, local and national printers happily provided Oxford's businesses with a surprising variety of picture postcards. Many scenes were produced using the latest color printing techniques, which gave the images a rather dreamy appearance that captured Oxford's storybook quaintness.

Situated on the Strand near the ferry dock, the Tred Avon Inn offered its guests cooling summer breezes and excellent views of the daily activities on the river and nightly sunsets. Visitors could fill a week or an entire summer sunbathing, boating, fishing, and picnicking. This building was demolished.

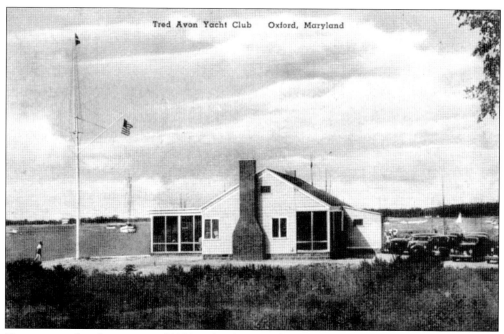

First organized in the summer of 1931 under the name "Kap Dun Club," the Tred Avon Yacht Club built its new clubhouse just downriver from the steamboat dock on Town Point in 1937. Informal sailing races had been taking place between local watermen for decades, but the club quickly became the headquarters for Oxford's recreational and competitive sailors.

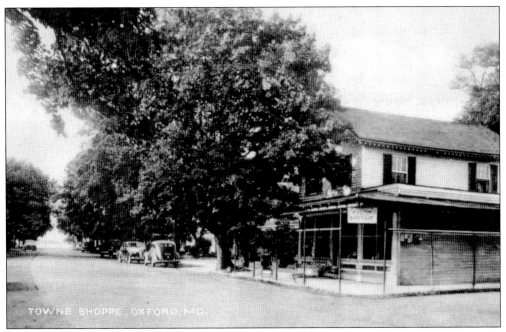

Located on the corner of Morris and Tilghman Streets, Louise Valliant's store was a favorite of both White and Black families in Oxford and visitors to town. Customers could purchase almost anything at the Towne Shoppe, its formal name, and spend a little time with "Miss Louise." It was said that she never changed the original price of an item, no matter how many years went by.

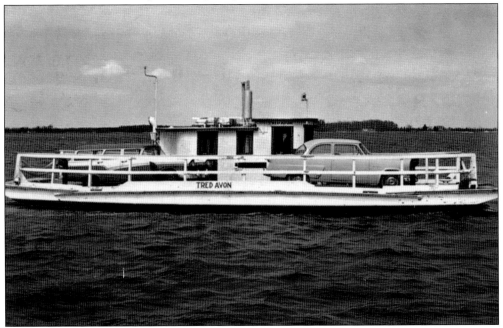

The Oxford-Bellevue Ferry has been an important part of life for Oxford residents ever since its beginnings in 1683. After Capt. Buck Richardson introduced the new gasoline-powered *Tred Avon* in 1932, the crossing became a much more enjoyable excursion that appealed to the growing number of tourists.

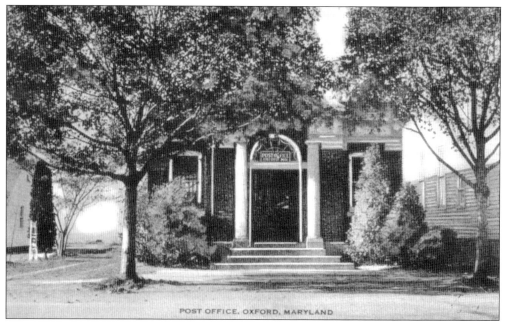

Originally built as the Oxford Bank in a prominent location on Morris Street, the brick building was reused as the town's post office after the disastrous failure of the bank in 1933. Today, it serves as a bookstore, with the original bank vault still intact.

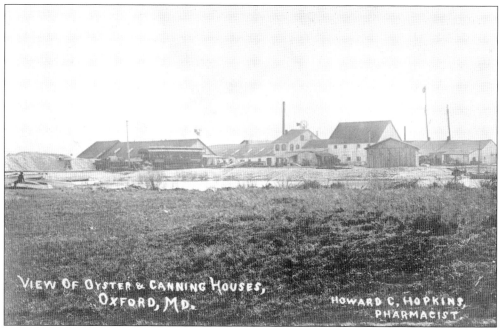

It is a testament to the importance of the oystering and crabbing business in Oxford that postcards like this were produced for sale to residents and tourists. What the cards could not convey was the overpowering smell that wafted over the town from the mountains of shells discarded from the packinghouses.

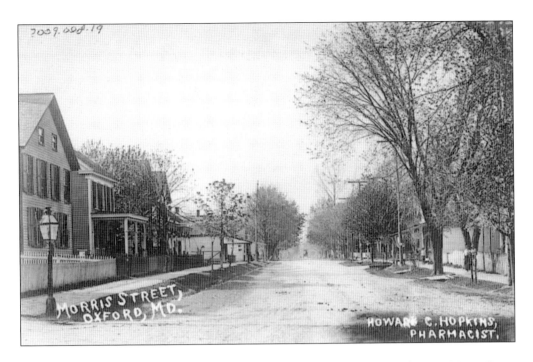

Originally called ye High Streete because of its relatively high elevation above the river, Morris Street remains Oxford's central avenue. Major businesses and the community's most prominent homes have always been located here, and it has been the main thoroughfare leading to the harbor and docks since the days of horses and carriages. The canopy of shade trees shown on this postcard still distinguishes Morris Street from the main streets of other towns in the region. Electric streetlights replaced the gas lamps in 1921, just as automobiles and their required gas pumps were becoming more common.

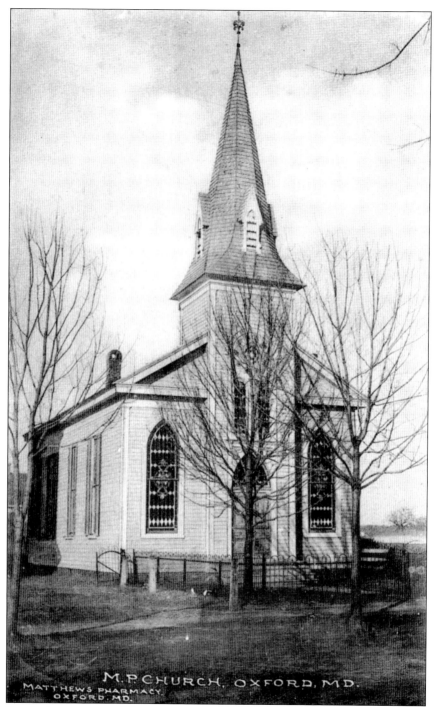

M.P. CHURCH, OXFORD, MD.
MATTHEWS PHARMACY
OXFORD, MD.

Methodism had a passionate following in Oxford. Following the Civil War, the congregation of St. Paul's Methodist Church split into two camps. Those who favored the cause of the South built their own wood-frame Methodist Protestant Church on the edge of the park in the 1870s and enlarged it in 1892 in response to the growing number of worshippers. The current brick Methodist church replaced it in 1948.

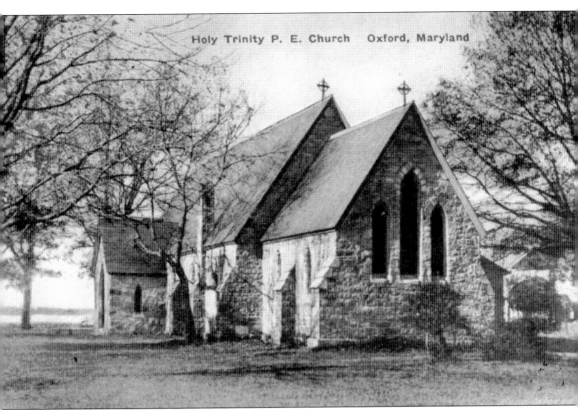

Holy Trinity P. E. Church Oxford, Maryland

Construction of Oxford's Holy Trinity Episcopalian Church was a project pursued by Gen. Tench Tilghman as a means for the cadets at the Maryland Military Academy to become Episcopalian. The cornerstone was laid in 1853. The stone for the church was hauled down from Port Deposit, Maryland, on the Susquehanna River at the head of the Chesapeake Bay. After the walls went up, the church's benefactor, General Tilghman, experienced financial loss. It stood vacant and abandoned as a picturesque ruin until work resumed in 1897. This view, dated 1905, shows the completed structure before a fire reduced it to four walls in 1945.

DISCOVER THOUSANDS OF LOCAL HISTORY BOOKS
FEATURING MILLIONS OF VINTAGE IMAGES

Arcadia Publishing, the leading local history publisher in the United States, is committed to making history accessible and meaningful through publishing books that celebrate and preserve the heritage of America's people and places.

Find more books like this at
www.arcadiapublishing.com

Search for your hometown history, your old stomping grounds, and even your favorite sports team.

Consistent with our mission to preserve history on a local level, this book was printed in South Carolina on American-made paper and manufactured entirely in the United States. Products carrying the accredited Forest Stewardship Council (FSC) label are printed on 100 percent FSC-certified paper.

MADE IN THE

USA